ARCHITECTURAL PHOTOGRAPHY

Introduction

Architectural photography, or the photography of man-made structures, presents problems that are unique to the cameraman.

Unlike the average photographic subject, such as a portrait, architectural photography must be approached with specialized equipment, and a highly selective and specialized way of seeing and working.

To try and record the architecture of structures which abound in modern profusion can be a challenge. And, to try and meet that challenge with small cameras such as the 35mm single-lens-reflex could defeat the real purpose of such an undertaking.

True, these modern 35mm cameras can be used to create striking *impressions* of modern architecture. Special lenses can be used to deliberately distort visual perspective, and selective angles can be used to create impressionistic photographs that, although remarkable in content, are in no way truly representative of the original subject.

However, in this volume, we are more concerned with recording the majestic beauty of sweeping lines, complex planes, broad expanses of glass, true perspective and whatever else is required to record professional and lasting photographs of these modern monoliths. And so, we must avail ourselves of a specialized camera, the view camera. With all of its remarkable features and abilities, it becomes *the* camera of record.

This volume, then, is not only devoted to an understanding of basic architectural photography, but to an understanding of the view camera and how it relates to this highly complex, exciting and rewarding field of photographic investigation.

Paul R. Farber / Editor
PhotoGraphic Magazine

SPECIALTY PUBLICATIONS DIVISION

Hans Tanner / Editorial Director
Erwin M. Rosen / Executive Editor
Robert I. Young / Art Director
Spence Murray / Editor, Automotive
Al Hall / Editor, General Projects
George E. Shultz / Editor, Spotlite Books
Don Whitt / Editor, Special Projects
Jeff Shifman / Editor, Research
Don Edgington / Editor, Outdoor Books
Ann R. Cornog / Mng. Editor, Automotive
Ronda Brown / Mng. Editor, Spotlite Books
Allen Bishop / Associate Editor
Jay Storer / Associate Editor
Harris R. Bierman / Associate Editor
Richard L. Busenkell / Associate Editor
Tom Senter / Associate Editor
Terry Parsons / Associate Editor
Jon Jay / Technical Editor, Automotive
Chriss Ohliger / Editorial Assistant
Steve Hirsch / Artist, Design
Pat Taketa / Artist, Design
George Fukuda / Artist, Design
Dick Fischer / Artist, Design
Celeste Swayne-Courtney / Artist, Design
Mark Gold / Artist, Illustration
Margaret Davies / Artist, Contributor
Angie Ullrich / Secretary

PHOTOGRAPHIC BOOKS

Mike Stensvold / Editor
Robert I. Young / Art Director
Lynne Anderson / Managing Editor
Guy Draughon / Feature Editor
Kalton C. Lahue / Contributing Editor
Joseph A. Bailey / Contributing Editor

PHOTOGRAPHIC MAGAZINE STAFF

Paul R. Farber / Editor
Cliff Wynne / Art Director
Jim Cornfield / Feature Editor
Mike Laurance / Technical Editor
Karen Sue Geller / Managing Editor
Joan Yarfitz / Associate Editor
Rus Arnold / Travel Editor
Steve Poster / Contributing Editor
David Sutton / Contributing Editor
Parry C. Yob / Contributing Editor
Brent H. Salmon / Publisher
Harlene McNair / Administrative Assistant
Mike Scardino / East Coast Editor
Carl Yanowitz / New York Advertising Rep.
Scott McLean / Los Angeles Advertising Rep.
Dan Dent / Chicago Advertising Rep.

ARCHITECTURAL PHOTOGRAPHY

By Kalton C. Lahue, Joseph A. Bailey and the Editors of PhotoGraphic Magazine. Copyright © 1973 by Petersen Publishing Co., 8490 Sunset Blvd., Los Angeles, Calif. 90069. Phone: (213) 657-5100. All rights reserved. No part of this book may be reproduced without written permission from the publisher. Printed in U.S.A.

COVER

Great Western Savings Center, Beverly Hills, California. Architects: William L. Pereira Associates. Photographed by Marvin Rand in late morning under overcast sky with a little sunlight coming through the overcast. Exposure was 1/8 second at f/22 on 4x5 Ektachrome film. Design by Robert I. Young.

PHOTO CREDITS

Title page, Central University Library, University of California, San Diego; architects, William L. Pereira Associates; photographed by Wayne Thom. Other photos in book by Big Cedar Studios, Brown Deer, Wisconsin; Calumet; Baco; Yankee; buyer's guide photos by manufacturers.

Library of Congress Catalog Card Number 73-82542

ISBN 0-8227-0027-1

PETERSEN PUBLISHING COMPANY

R. E. Petersen / Chairman of the Board
F.R. Waingrow / President
Robert E. Brown / V.P. Nat'l Advertising Director
Herb Metcalf / V.P. Circulation Director
Philip E. Trimbach / Controller-Treasurer
Robert Andersen / Director, Manufacturing
Al Issacs / Director, Graphics
Bob D'Olivo / Director, Photography
Spencer Nilson / Director, Administrative Services
Mitza B. Thompson / Director, Advertising Sales Administration

Larry Kent / Director, Corporate Merchandising
Ronald D. Salk / Director, Public Relations
William Porter / Director, Single Copy Sales
Jack Thompson / Director, Subscription Sales
Maria Cox / Manager, Data Processing Services
Mel Rawitsch / Manager, Manufacturing Planning
Robert Horton / Manager, Traffic
Harold Davis / Manager, Production
James J. Krenek / Manager, Purchasing

Contents

To View or Not to View

One of the few remaining bastions of photography still the province of the press/view type camera, architectural photography is unlikely to ever be permanently conquered by any other type. SLR and TLR users have but limited abilities with their otherwise fine cameras before the combination of converging vertical lines, limited depth of field, obstructions in the field of view and the human eye itself puts them out of business. To understand why, stand near a tall building and look up.

Even though its parallel lines are actually converging when seen by the eye at this range, the brain rejects the visual impression by creating a visual accommodation. As a result, we do not see vertical lines as converging at the upper end but interpret them instead as continuing to remain parallel to each other. Because the camera lens does not have the luxury of such accommodation powers (and in this case does not lie), the finished picture will show the lines as converging and may even give the impression that the building is about to topple over backwards. To continue the paradox to its illogical end, when we look at such a picture, our brain "knows" that something is incorrect and tells us so. To avoid this, the architectural photographer uses camera corrections in his work.

LIMITED CORRECTION METHODS

Except for a few 35mm cameras and the Rollei SL66 single-lens reflex, corrections are limited to press/view cameras, for only they have the necessary adjustments to compensate and provide the corrections required for architectural work. Nikon provides a 35mm Perspective Control (PC) lens that fits only its cameras, while Canon offers a 35mm Tilt & Shift (TS) lens for its users. Schneider manufactures a 35mm Perspective Adjustment (PA) Curtagon lens in the Pentax/Practica and a few other mounts for certain 35mm cameras. These lenses can be moved between five and sev-

en millimeters from their elliptical axis to correct perspective when photographing tall buildings, etc., and if shifted to the side, the lens can also correct horizontal perspective to some degree on wide subjects.

But their usefulness is hampered by the limited amount of shift (about 20-25 percent of that provided by most press/view cameras), as is the Rollei SL66 by the few degrees of swing of which its bellows is capable. While it's possible for the user of such cameras to correct convergence by either tilting the negatives in the enlarger or tilting the easel, this technique of distortion control really has but a limited application and is usually reserved for experimental special effects or as a last resort in "saving" a picture, as the image usually appears to be elongated or compressed in relation to that of a straight print made from the negative.

Some professionals make a copy negative containing the enlarger corrections and then enlarge it once more to make further correction, but this is impractical in all but extreme cases. Deliberately tilting the camera cornerwise so that the main part of the subject is on a diagonal is another method of using a camera that has no corrective movements. The lines will still converge but the effect is unusual to the eye and escapes the censorship of our brain. Such pictures can often be found in magazines but fall under an artistic, interpretive or stylistic approach to the subject and do not constitute more than a small percentage of sales in the architectural field.

Only the press/view camera is versatile enough to handle the degree of compensation usually required in architectural photography and of these, the view camera is best suited as none of the relationships between its principal parts is permanently secured. Both the front and back of the camera can be locked in any of a hundred-odd positions and so the adjustment of the relationships to suit a

given photographic situation makes the view camera both ideal and universal in its application. As the standard press camera can be adjusted in somewhat the same manner, it can often be used in place of a view camera. But the view camera is the best choice as the amount of adjustment possible is usually considerably greater than that provided by the press type of camera.

So if you're interested in architectural photography other than as an occasional means of artistic and esthetic expression (where SLR and TLRs are well-suited—try an 8mm Nikkor Fisheye just for kicks), you'd better think about adding the right type of camera to your basic equipment—and here's why.

VIEW CAMERA MOVEMENTS

View cameras (we'll consider press cameras later on) are constructed with three fundamental frontal movements: the rising/falling front, sliding front and lateral/vertical swings. Combined with similar swings and tilts of the back, the user finds it possible to handle any perspective corrections he needs to make, provided that his working knowledge of their function is sufficient to allow him to choose the proper combination and use of the camera movements.

1. You may do occasional work with other cameras, but if architectural photography is where it's at for you, you'll find a view camera like this Calumet Wide Field the only way to go.

2. Deliberate tilting of camera or subject (or both) is one way to minimize convergence with non-correction type of camera. Resulting convergence between tree and building is about 50 percent, but palm leaves tend to fool the eye into believing it to be less and so more acceptable.

3. While the brain creates a visual accommodation to prevent our eye from seeing the convergence of vertical lines, the camera cannot do so. As the 35mm SLR has no correction methods, this is the result, highly unsatisfactory as an architectural study.

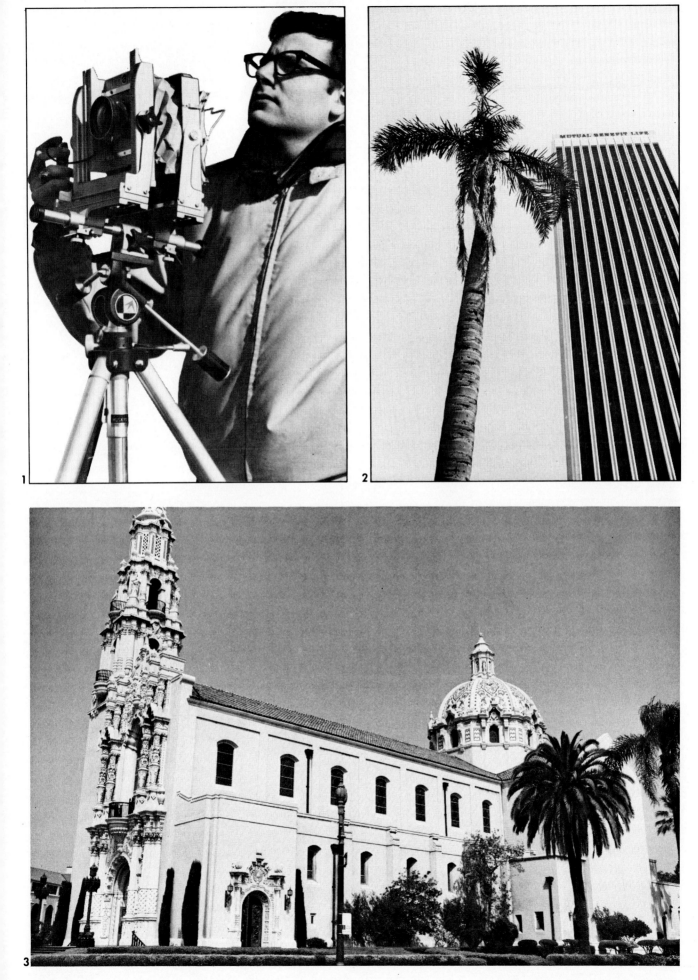

To View or Not to View

Rising/falling front/ The function of a rising front is shown diagrammatically in Figure A. With the camera level and pointed at the subject (a), only a portion of it can be seen by the lens. Tilting the camera upward (b) brings the entire subject into the lens' angle of view but as the parallel lines converge at the top, as in a Keystone effect, this introduces distortion. Bringing the camera again to a plane that's level with that of the subject, but raising the lens in relation to the center of the negative (c) extends the effective angle of view in a vertical direction and gives a correct photographic image. The falling front allows dropping of the lens in relation to the negative's center and is similar to the rising front both in operation and in function. It's also necessary when using certain wide-angle lenses on some cameras.

Sliding front/ This horizontal displacement of the lens relative to the negative center is functional similar to that of the rising/falling front. The sliding front can be used to photograph an object from off-center while making the picture appear to have been taken directly head-on. Such a camera movement can often be the architectural photographer's answer to the problem of telephone poles, signs and similar obstructions that would otherwise interfere with a graceful and pleasing composition of the picture were it actually to be taken from directly in front of the subject. A sliding front comes in handy when using the camera from an awkward position, photographing interiors from a crowded corner or eliminating reflections from a shiny surface where polarization of light source or subject is impractical or impossible.

Further, such effects can be achieved by mounting the lens off-center in its lens board, but such extreme use of the adjustment capability here may tax the covering power of your lens. Provided the camera is positioned level, with the negative parallel to the subject and the lens axis perpendicular to the negative, none of these frontal movements has any effect on a geometrically correct rendition of the subject. If the negative plane is parallel to the subject plane, there can be no convergence or divergence in the subject's lines. Thus, regardless of the position assigned to the lens in relation to the location of the negative, the raising, lowering or sliding of the lens can in no way affect the correct rendering of the image as long as the limit of the lens' covering power is not exceeded (Figure B).

We should point out here that while

1

2

using the rising front may seem to be the most simple and direct means of adjusting the view camera for perspective control, adjustment by means of the swings and tilts gives a much wider degree of correction. Thus, it's best to use the raising and sliding front for minor compositional adjustments after first making the major corrections required with the swing and tilt capabilities.

Front tilt and swings/ A problem may be encountered whenever the axis of the lens has to be tilted, for whatever reason. As we've seen, the parallel lines of the subject will not change under such a tilt condition, but focus discrepancies will often occur as a result. This is where the front swing movement, often considered to be the most important frontal movement to the user, comes into play. Using this swing correctly, it's possible to increase depth of field significantly without stopping down the lens, often to a degree impossible with other types of cameras, even when an identical focal-length lens is fully stopped down.

Should lighting conditions demand the use of a large lens opening with its resulting limited depth of field, tilting the lens board can bring the entire subject into focus without altering its shape. To understand why without getting into the finer points of geometry and optics, you should remember

1. With the swings and tilts of the press/view camera, pictures like this are possible. Picture taken at same position with camera such as Rolleiflex TLR would make building appear to be falling over. Actually, a Rollei couldn't cover a very tall building at a position this close.

2. Rise and fall are used to eliminate foregrounds and center image without resetting camera swings that were previously adjusted.

3. Baco enlarger is good choice for inexpensive control of converging lines as it can be tilted and locked in place with ease. This condenser enlarger accepts negative sizes from 35mm to 2¼x3¼.

4. Sliding front or side shift lets you move lens axis without moving the camera or disturbing the already-adjusted swings.

5. It's possible to correct distortion in the darkroom by tilting the enlarger or easel as shown in A and B. Regardless of which is easiest for you, depth of field will be quite shallow and the enlarging lens should be stopped down. If your enlarger is sophisticated enough to allow tilting of the negative carrier and lens as in C, the image plane will be uniformly sharp with lens wide open.

6. Value of rising/falling front is shown in diagrammatic sequence. A is unacceptable because entire building cannot be captured by lens. Tilting camera upward to get entire subject image creates a converging of parallel vertical lines (B) but using rising front restores perspective (C).

FIGURE A

that the distance between lens and film must be increased as the camera comes closer to the subject. As a result, the required lens extension for a distant subject is less than for one that's close to the camera. If both near and far points of the subject are in an inclined plane relative to the lens axis, a front swing movement will allow both to be brought into sharp focus at the same time, as shown in Figure C. When combined with a back swing, the angle of correction is even greater, as in Figure C-1.

Sometimes the front of the camera may have to be raised so high that it will decrease illumination in the upper corners of the ground glass. This vignetting effect can be overcome by tilting the front slightly. Although this changes the lens axis, it will also provide even distribution of the light with no noticeable distortion on the negative you shoot in this way.

Vertical back swing/ As it preserves the parallel relationship of the negative to the subject plane, the vertical back swing is probably the adjustment most often used in architectural photography. If a given subject is too tall to be completely included in the field of view even when the rising front is used, the camera can be tilted upward and the vertical back swing used to restore parallelism of the negative with the subject. As this may cause a discrepancy in focus, tilting the lens axis slightly, as we've seen, is usually sufficient to restore a considerable amount of depth of field.

Horizontal back swing/ The horizontal back swing is identical in function and use with that of the vertical swing except that it's used to deal with horizontal parallelism or focus differences, finding its greatest use in correction of an exaggerated per-

spective when the camera is used at an angle to the subject. If the degree of sliding front movement is insufficient and the camera must be turned to one side in order to bring the entire subject onto the negative, use of the horizontal back swing will retain the parallel horizontal plane requirements of negative/subject. You'll find horizontal perspective to be less troublesome than vertical perspective as it's encountered less often; if an angular view of a building is required, no horizontal linear corrections are needed. In the majority of instances, the horizontal back swing is most valuable in compensating for focus differences in scenes.

Front/back focusing/ The front and back assemblies can be moved on the camera bed of many view cameras and so it's possible to focus with either of them. Back focusing is inval-

To View or Not to View

uable when working with close details such as architectural models, as the image size can be absolutely controlled by carefully setting the camera back-to-subject distance and correcting the focus with the front. On view cameras equipped only for frontal focusing, any image size adjustment or control must be accomplished by moving the entire camera/tripod setup forward or backward.

USE OF CAMERA MOVEMENTS

As we've seen to a brief extent so far, view camera movements can be used to correct more than the simple distortion involved whenever the camera is tilted upward. In addition to such perspective control, there's camera position correction, to which we briefly alluded earlier. With passing time, it becomes more difficult to obtain the complete freedom of movement that was more genuinely available to photographers at say, the turn of the century. Progress inevitably means more roads, streets, traffic, people, obstructions of view and downright difficulty in plunking a view camera and tripod exactly where it's best suited to reproduce a scene. And in rural areas, Mother Nature has often stepped in with natural terrain features that make architectural photography a fascinating challenge.

But it is possible to "cheat" to a considerable degree when using a camera with movements; suppose that you must photograph a new store front for a client and he desires a direct head-on shot. Had you received the assignment a couple of weeks earlier, things could have gone smoothly, but the store was not ready at that time and now that it is, you find that another building is being constructed on the exact spot where you planned to place your camera. Only a view camera with its multitude of corrections can save the day here.

Choosing an alternate postion beside the new construction to set up your camera, you can now cover the

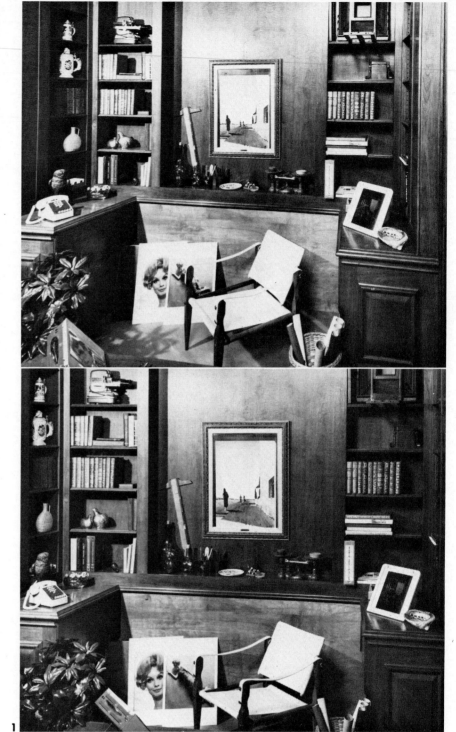

1

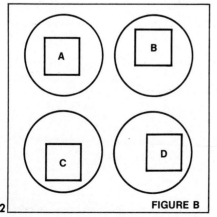

2 **FIGURE B**

3 A B **FIGURE C**

entire store front, but the image on the ground glass will not be that of a pure frontal view; it will be shorter at one side than at the other. So you swing both front and back of the camera to bring them into a plane parallel with the store front and now the image on the ground glass is correct, almost as it would be if your camera could be positioned directly in front of the subject. Why not exactly?

Well, the lateral aspect of a projecting entrance, for example, cannot be suppressed completely but such minor distractions are seldom noted by the eye when viewing the finished print. Were you to photograph a two-dimensional object in this same manner, it would be impossible to distinguish from one taken directly in front of the subject. This can be an ideal way to overcome reflections when light control is impossible while photographing architectural renderings or sketches.

FALSIFYING PERSPECTIVE

We've already discussed the restoration of perspective with a view camera, but perspective control also includes the ability to completely falsify it. As the eye accepts a horizontal convergence of receding parallel lines as being quite normal, horizontal swings are not often used in routine work. But by combining the use of horizontal and vertical swings, you can achieve an isometric perspective

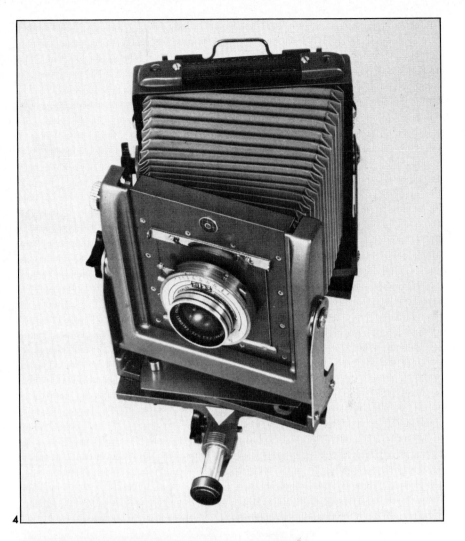

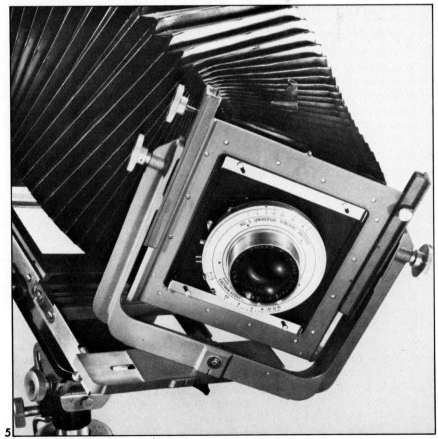

1. These two interior pictures were taken from a distance of 10 feet. Some distortion of vertical lines is evident in shot at top, but careful use of swings and tilts provides good correction of both vertical and horizontal lines, giving an acceptable picture (bottom) despite difficult working conditions, limited space.

2. Diagram shows effect of rising/falling/sliding front and relationship between lens and negative image. The circle represents the covering power of the lens; the square is the image on the negative. A represents normal usage; B and C show the rising and falling front in operation respectively, and D shows a side shift.

3. The Scheimpflug Rule states that in order to bring near and far points of an inclined plane into sharp focus, lines extended from subject, lens and negative planes must intersect. A shows a partial application using only a front swing, while B illustrates complete application by combining front and rear swings.

4. By placing near objects on one side of lens axis and far objects on the other, camera swings can be used to hold both in sharp focus.

5. Front horizontal swings should pivot on the axis and shift to either side. While valuable for perspective control, front swings are even more useful to control depth of field.

in which no convergence of lines takes place—all lines that are parallel to the negative plane are thus reproduced in their true relative lengths despite their distance from the camera. If you're beginning to feel somewhat like a contortionist, it's with good reason for here we can make the camera lie with a vengeance. When cheating in this manner, you'll need the use of a long-focus lens as you'll be using the edges of the lens field primarily. And as residual aberrations do remain at the limits of the field of your lens, use of a small lens opening will be required in this case.

CONTROLLING PERSPECTIVE DISTANCE

Objects placed at varying distances from the camera will result in images of differing sizes, O.K.? Their relation in the finished print gives the eye an idea of and clues to their distances from the camera and so creates the perspective of the picture. But once again, we find it possible to control this type of perspective with the view camera, and more easily than with any other type.

Let's take a simple example of two objects in front of our camera, as shown in Figure D. Although both are the same size in reality, the first (X) is exactly twice as far from the camera as the second (Z). The image of X on our ground glass (X-1) will now be exactly one-half that of Z, or Z-1. Now we'll change to a longer-focus lens and move the camera back until Z is twice as far from us as before. Z is now two-thirds of the distance from us that X is and so the image of X is two-thirds that of Z. Put simply, this exercise has made the objects appear more equal in size by moving the camera farther from them and changing the lens. Want to reverse the effect? Just move the camera closer and use a short-focus lens.

USING A PRESS CAMERA

Press cameras allow similar corrections to those of a view camera but to a much lesser degree and so are not as universally useful to the architectural photographer. Many are limited to a rising/falling/tilting front but some models of the Linhof also have a swing back. The Linhof and Speed Graphic do make provision for certain horizontal corrections but these are so slight as to be insignificant to the serious worker. Of the press-type cameras, the Horseman Technical is closest to a view camera in its ability to deliver view camera results.

While we've merely explored the surface of what can be accomplished

1

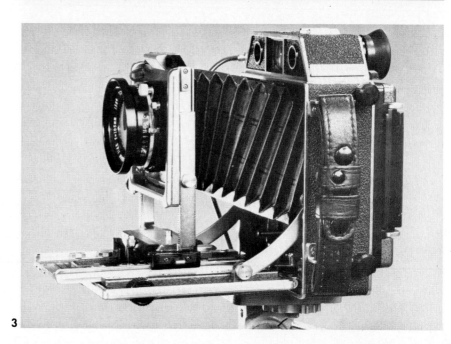

2

3

4

1. *Here's the effect of using swings to increase depth of field. When using camera and lens without swing, plane of sharp focus is same as optical depth of focus of lens. Had we focused on mid-point, only that would have been sharp. Obvious answer seems to be "back up" but because of space limitations behind photographer, this was not possible.*

2. *Problem of focus was solved by swinging camera's back and front. If you swing back away from near objects and the front toward far objects, it is just as if you were focusing individually on each segment of subject.*

3. *Horseman Technical Camera has a healthy degree of rise in its front and is without peer in press camera type for architectural work.*

4. *This set of adjustments would be used in photographing architectural models. Camera back and lens are still parallel with subject, but camera is now shooting down on subject.*

5. *Sliding front of Horseman camera is sufficient to offer good amount of correction without moving camera or disturbing basic swings, tilts or camera angle.*

6. *(Top) An object twice as far from the camera (X) as nearest one (Z) will give a negative image half the size. But move the camera twice as far from the nearest subject (bottom) and substitute a longer focal-length lens and the negative image of X will be 2/3 the size of that of Z, making them more equal in size on negative.*

7. *Here's a combination of movements in use. Camera back is aligned parallel to subject. Lens is also parallel to subject and camera back for crisp focus. Rising/falling front permits fine adjustment of image without moving camera and disturbing front and back adjustments already made.*

8. *As with front swings, back should pivot on optical axis and slide left or right as desired.*

with a view camera, it's time to move on. An entire book could be written just dealing with the effects possible by proper use of camera movements (and several have been), but as our aim is to get you into the swing of architectural photography as quickly as possible, and our space to do so is necessarily limited, let's explore the basic equipment requirements next. ♛

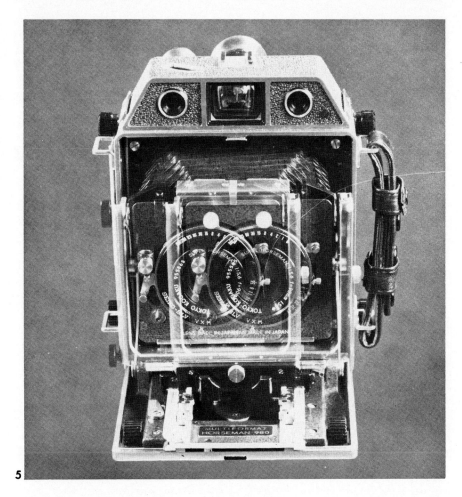

5

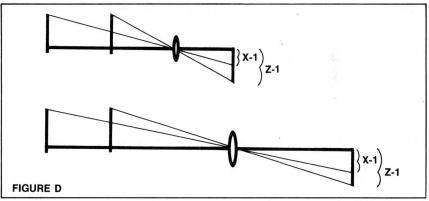

FIGURE D

6

7

8

Looking Through the Ground Glass

Exactly how much you will be able to accomplish in architectural photography will depend to a large extent upon just how versatile your view camera really is. While there are many instances in which ingenuity can help overcome the limitations imposed by the use of an inexpensive camera (after all, isn't necessity the mother of invention?), we feel that those who are starting out in the field should not burden themselves unnecessarily. The cost of a good view camera with most or all of the desirable features is considerably less than that of the majority of medium-priced 35mm cameras and so there should be little reason to stint here. You can, of course, find view cameras whose cost would make an excellent down payment on a new automobile, but the beginner doesn't really need the luxury provided by such. Where you will find costs somewhat prohibitive is when you start to build a battery of lenses, but again, there is a reasonable solution to that problem which we'll explore.

CAMERA FEATURES

As view cameras constitute a very small segment of the photographic hardware market these days, most small or medium-size photo shops don't even carry them in stock. Expect to find discounts and price-cutting somewhat difficult to come by unless you chance upon a dealer who has one left on hand that he's been unable to move. So the first requirement is simply—be prepared to pay the price. Now, what should you look for in terms of features?

Unlike the 35mm SLR market, where camera features are pretty well standardized according to price range, view cameras are as individual as those who use them, but there are certain things you should definitely look for. To begin with, it will be necessary to first settle upon a film size or format—4x5, 5x7 or 8x10. While many feel that the larger the negative, the better the quality of the final print, there's no reason why a 4x5 shouldn't prove quite satisfactory in terms of quality, and from a financial standpoint, it's the most practical—the difference in film costs is really minor, but the savings on lenses alone can pay for the camera several times over!

Having decided upon the film size with which you wish to work, the models you consider should have a full complement of movements—the rising/falling/tilting/sliding front, vertical and horizontal back swings and front/rear focusing, although this latter feature will only be found on the more expensive in the line. These are mandatory features necessary to make your work possible; the remaining ones considered below are features that will make your work easier and faster.

1. A revolving back for quick alignment of the format without having to move the camera; should have at least 180-degree and preferably 360-degree movement. Click stops to indicate precise horizontal and vertical positions are a decided advantage.

2. Sufficient bellows extension to accommodate the variety of lenses for which you anticipate a need. Ordinarily, you'll find a double-extension bellows of 15-16 inches adequate; a longer one often comes in handy if you're working with architectural models or copying, as it makes possible moving in very close to the subject for a larger negative image.

3. An adjustable tripod block lets you position the camera for balance without moving the tripod. Especially desirable when using extreme up or down angles.

4. Horizontal and vertical levels atop the camera for quick alignment of the back despite use on terrain requiring an uneven adjustment of the tripod legs. If the camera you select does not have the built-in variety, purchase a small carpenter's level. The use of some sort of leveling device is essential as only a slightly off-level position of the back may well appear as a noticeable distortion of line in the final print. This is especially true when wide-angle lenses are employed and regardless of how good you are at ''eyeballing'' under other circumstances, it's almost im-

1. Those new to the view camera will find an overwhelming variety of lenses available, but we'll help you narrow field down to manageable proportions.

2. Camera back that revolves 360 degrees, as on this Calumet CC-400, is definite advantage for the architectural photographer.

3. Calumet CC-400 illustrates normal double extension bellows desirable in good view camera; 16-inch extension will handle all normal work.

4. Triple extension of Calumet CC-401 has 22-inch bellows and is excellent for close-up work with architectural models where detail rendering is necessary.

5. Tripod block that slides along the bed allows fine positioning of camera without moving your tripod and disturbing swings and tilts.

6. Horizontal and vertical levels are built into Calumet back and are one less accessory you have to carry along on job with this camera.

7. Fine-grain ground glass scribed with half-inch rules helps in composing your pictures. Accuracy of ground glass positioning relative to film plane must be high and is one of several reasons for testing a used view camera before buying.

8. Release lever to relieve spring tension when inserting film holders or roll backs will prevent inadvertent moving of the camera.

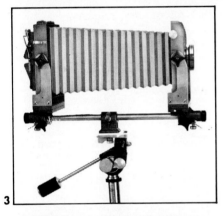

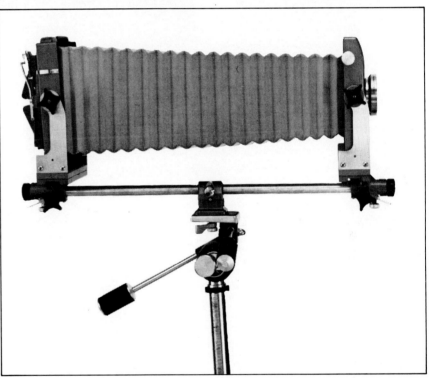

possible to check back alignment by looking at the ground glass image, even with the scribed glass, our next point.

5. A fine-grain ground glass of good quality and scribed with both horizontal and vertical dimensions helps in composition.

6. A film release lever on the camera back relieves tension and allows film holders to be inserted without jarring the camera.

7. Positive locks on focusing drive(s) and camera movements.

8. Oversize and easy-to-reach controls for fumble-proof operation.

NEW VS. USED

Should you consider the purchase of a used view camera? If you can locate one that fits your requirements, we can see no valid objections to it as long as you observe the following:

1. Check the operation of all movements very carefully. Take a number of pictures with the camera if possible before parting with the cash. At the guarantee after an agreed-upon trial period.

2. Pay special attention to the condition of the bellows, as renovating one with pinholes or other tiny but hidden defects can be as costly in many cases as buying a new camera, especially if the one under consideration is a long-discontinued model whose manufacturer has long-departed the photographic scene.

3. Make sure that the wooden frame is not warped. Again, "eyeballing" the frame is not a sure way to check; it's better to use a metal straight-edge.

4. If the camera has the newer metal monorail construction, check to be certain that it's in correct alignment. Dropping a view camera can cause many problems not apparent to the eye.

You can often do quite well in terms of price as the used market for view cameras is not especially lively these days either and the selling price will often include a lens if you buy from a private party. Photoshops that take used view cameras in trade often detach the lens and sell it separately, as in most cases its marketability is considerably greater alone than with the view camera body attached. All of which brings us to another aspect that's as important as the camera itself.

LENSES

As there's probably more glass available for press/view cameras than for any other type, the world of optics can turn to instant confusion for those not familiar with the needs and requirements of large-format cameras. While your immediate concern is to acquire a single general-purpose lens that will meet at least 80 percent of your needs, you'll also find a wide-angle to be of considerable help in many situations. Both lenses should be fine-quality anastigmats possessing extensive covering powers.

Selecting the right focal length/

As view camera lenses come in a wide variety of focal lengths, this proves to be the first area of confusion. The usual method of determining the "normal" focal length is to measure the diagonal of your negative, selecting a lens whose focal length is the same or slightly larger. Thus, to adequately work with a 4x5 negative, you'd need a 6½ inch (165mm) lens by this reasoning.

But because a lens used on a view camera is often moved off-axis for swings, tilts, rise and fall, you'll find it more practical to have a longer than "normal" focal length as your basic lens. The use of the longer focal length also produces a sufficiently larger negative image without having to move in too close to the subject and at the same time, this increase in distance between camera and subject helps to minimize distortion. The minimum image circle diameter required to cover the negative's diagonal perfectly with even illumination from corner to corner is 161mm with a 4x5, 219mm with 5x7 and 323mm for an 8x10 negative size.

As most lenses will cover more film when stopped down, shorter lenses can be used but don't expect too much in the way of swings and tilts, as Figure A demonstrates. While certain focal lengths are better for the type of work generally encountered by the architectural photographer, no one lens will do every assignment, so although you may start off with but a single lens, you'll soon find need for others. Table 1 suggests four basic focal lengths for the 4x5

1. Shorter than "normal" lenses can be used when stopped down, but limit amount of swings and tilt that can be used. Drawings show what happens when covering power of lens is exceeded, cutting off part of subject.

2. Perspective control by choice of lens focal length is shown is series taken in Las Vegas with Horseman Technical Camera. Subject perspective is normally altered by the distance between camera and subject. Once the distance is established, pick focal length that allows you to fill the negative area. Little perspective distortion can be seen in this wide-angle scenic. A 65mm lens was used with some swing and camera level.

3. Perspective control is still good when 90mm lens is used. Unsightly structure at right has been eliminated.

4. A 105mm lens was used here. As you can see, subtle changes can be made in subject by choice of focal length, proving that there's no "correct" focal length—it all depends upon your particular needs.

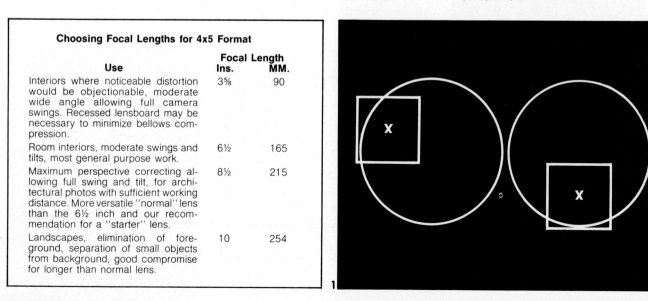

Choosing Focal Lengths for 4x5 Format		
Use	**Focal Length**	
	Ins.	**MM.**
Interiors where noticeable distortion would be objectionable, moderate wide angle allowing full camera swings. Recessed lensboard may be necessary to minimize bellows compression.	3⅝	90
Room interiors, moderate swings and tilts, most general purpose work.	6½	165
Maximum perspective correcting allowing full swing and tilt, for architectural photos with sufficient working distance. More versatile "normal" lens than the 6½ inch and our recommendation for a "starter" lens.	8½	215
Landscapes, elimination of foreground, separation of small objects from background, good compromise for longer than normal lens.	10	254

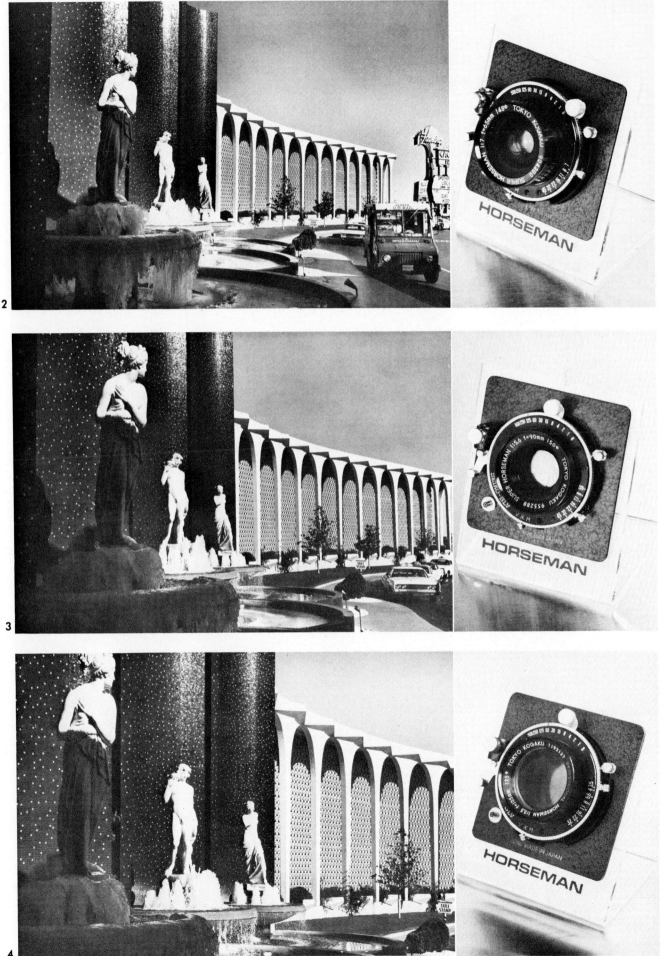

format and their application for architectural work.

One school of thought still prefers the convertible lens. This has the versatility of incorporating three different focal lengths in one lens; as the front and rear components are individually corrected lenses by themselves, either can be used alone as well as in combination. The shortest (and "normal") focal length is obtained when both components are used together; the focal length of each component used alone is different and always longer than the "normal" focal length. The convertible lens has greatest speed when all three components are used together; separate components are usually somewhat slower when used by themselves.

Lens speed/ You won't find the large aperture lenses used with other cameras when shopping for a view camera lens—they aren't available and really aren't necessary. What you're looking for is sharp definition and to get it, you'll stop the lens down in most cases, perhaps to f/32 or f/45. View camera lenses are very highly corrected and involve the use of large glass surfaces and a maximum aperture of f/4.5 is considered to be a very "fast" one. You'll find f/5.6 or f/6.3 to be usual and many wide-angle lenses have a maximum aperture of f/8.

SHUTTER

In these days of wide-range and high-speed shutters, it's natural to consider a top speed of 1/500 or 1/1000 second as indispensible, but for the architectural photographer, a shutter speed range of 1 to 1/150 will prove to be completely adequate. Remember, you're not going to be photographing moving objects, nor will you work very often with the fast emulsions requiring such extremely short exposures. The bulk of architectural photos will be taken at a small lens opening and a relatively slow shutter speed, so don't worry too much about what appears to be a limited shutter speed range; devote your attention to the selection of a shutter that's both accurate and dependable, and you'll do well.

The question of flash synchronization comes to mind as most modern shutters are so equipped. If you purchase a new lens/shutter, the question becomes purely academic as flash sync is there, but should you consider starting off with a used lens/shutter, and the used market is inundated with them as you'll see from a quick browse through any large photo store, should you insist

on flash sync? We'd say that to do so would be to automatically exclude from your consideration many fine lenses that can serve your purposes quite admirably and at a reasonable cost. Flash sync for the architectural photographer is primarily useful when shooting interiors where flash is used for balance or to fill hard-to-light areas.

For those who move into architectural work as a natural extension of their photographic interest, working with the constant illumination provided by standard lighting equipment instead of flash is probably the easiest and fastest way to master the techniques of balancing interior illumination. In this way, you can check the results of light placement at every step of the way on the ground glass instead of waiting until the negative has been developed to see if the flash was correctly placed and properly balanced. If you're already a whiz at this sort of thing, you may prefer to skip the learning experience and move onto greater things, but don't let the lack of flash sync prevent you from considering a good used lens. This is one dandy way to help hold costs down if you're just starting out.

ACCESSORIES

Settling on the use of a view camera automatically brings a tripod into the picture, as there's no way you can hand-hold one of these. Because you'll often be working with the slower film emulsions and small lens openings, the importance of a good tripod—one that will hold the camera perfectly still and firmly in place—is obvious. In fact, it's quite likely that you'll spend almost as much money for a sturdy tripod as you will for the basic camera (without lens). Whether you use one of the older style wooden tripods or buy one of the modern metal designs is not as important as the ease of adjustment and operation, along with the rigidity which it offers the camera.

Your choice of tripod should be one designed for use with a view camera, extending at least to eye-level. As much of any tripod's rigidity rests in its head, look for features like a large camera plate (2x3 inches at least) and a friction-lock center post; if you can afford it, a worm gear elevator center post is even better. Side tilt should be 90 degrees to the left, 40 degrees to the right, while forward tilts of 90 degrees down and 45 degrees up along with 360-degree rotation are a must. A tripod dolly is ideal for interiors as well as for some exterior shots, but for the beginner this can be considered as a luxury until that first sale has been made.

2

3

4

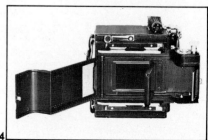

1

You'll need a carrying case for the camera and one for the tripod; the latter can be one made of fiber but try to stay with a lightweight aluminum case for the camera and insist on foam rubber padding for the extra protection that it affords.

Film holders offer several advantages over the roll film backs available for most view and all press cameras. You can load a dozen holders with a wide variety of films and process only those actually used, cutting down on the waste of half a roll or more if you need to see your results immediately. This advantage is offset by the bulk and weight involved in carrying a dozen holders with you on the job as compared to a roll back and a couple extra rolls of film—but the real pro will have several roll backs, each loaded with different emulsions, as well as holders.

As sheet film has a stronger and less flexible base than that of roll film, it's preferable whenever retouching

may be involved. You'll also find the greatest variety of special emulsions available in sheet film and that roll film is simply out of the question when it comes to special effects such as infrared because no one makes the desired emulsion in 120 or 220 sizes. Sheet film also affords a greater degree of control in development as you can process each shot individually to control density and contrast. For the beginner, we recommend that you start off with a single roll holder and six film holders. These

can often be purchased in used condition at a considerable savings over their new cost and unless they have been subject to inordinate wear and abuse, should be quite satisfactory. We'll touch on other aspects in greater depth when we consider what films to use.

To see what you're doing behind the camera, you'll need a black focusing cloth to shade the ground glass from extraneous light while composing and focusing the picture. Some view cameras are equipped

1. All operating controls should be oversize and when camera is collapsed, it should be as compact as possible.

2. Lightweight but solid tripods manufactured by Gitzo have reversible center columns and can be equipped with variety of heads. This type of tripod is good choice for photographer who wants easy-to-carry general-purpose tripod for use with all cameras up to and including 4x5 size.

3. Novel tool for architectural photographer who needs to vary his angle is Gitzo Gitzechel-Gitfix ladder-tripod that combines nine-step ladder with tripod. Although it weighs 38 pounds, it collapses to 18 inches while extending to 130 inches at a moment's notice.

4. C-2 holder slips into all standard press/view camera backs and also attaches to cameras equipped with the Graflok back.

5. Baco offers Jr. and Sr. Hollywood head with forward edge shaped to provide for drop-bed cameras when using wide-angle lens. Head is reversible to provide offset for vertical camera use.

6. Soft bellows design of Calumet's Wide Field CC-402 permits maximum flexing without restriction and gives benefits of a "bag bellows" without sagging into picture area.

7. Use of wire frame to support the focusing cloth forms tent around camera back, keeps cloth in place.

8. Pan head's camera plate must be large enough to accept camera's tripod block. Look for match such as this provided by Calumet View and a Quick-Set Hi-Boy IV.

9. Front and rear views of Calumet Optical Exposure Computer. Available in both 2¼x3¼ and 4x5 versions, this extremely precise device measures the light at negative plane for excellent results under all conditions.

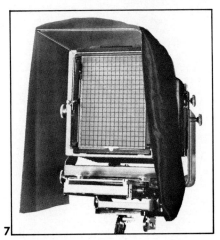

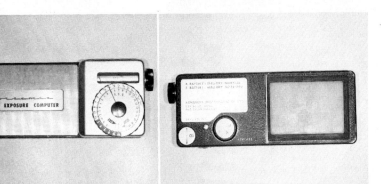

Ground Glass

with a wire frame that forms a tent of sorts around the ground glass; these are quite handy as they secure the cloth and prevent it from blowing away in a sudden gust of wind. And for the fashionable, the wire frame prevents the focusing cloth from mussing the photographer's hair. A focusing magnifier can be a lifesaver, especially when working with interiors or under other low-level light conditions and should be part of your basic system. Use it particularly to check corner illumination and covering power of the lens under extreme conditions of swing and tilt.

As the prevention of off-axis light from striking the lens and causing flare is of vital importance to you, a lens shade and filter holder should be added to the basic equipment list. One of the best is the bellows type which secures to an adapter block mounted on the camera. While using standard lens adapter rings and filters that you might already have on hand sounds like a nice economy move, it's the mark of the rank (or poor) amateur. Your basic lens complement will consist of two or more focal lengths and playing with filters and adapters of different and often incorrect sizes will offer nothing but headaches to you.

A good bellows shade should slide on a double rail to give easy access to the lens settings and can be swung and tilted to prevent cut-off while at the same time offering maximum shading of the lens regardless of how the camera has been adjusted. It will also accept filters (gels or glass) in a holder and have a pair of front clips to allow the use of acetates or mattes for special effects. With these clips, you can bring diffusers, vignettes and other masks into or out of focus by a simple adjustment of the bellows length.

You'll need an accurate exposure meter capable of reading a wide range of light levels. While every pho-

tographer has his own preference as to type (reflected vs. incident light) and make, we'd like to bring to your attention one for the well-heeled beginner that will take much ache and pain from his life. Calumet markets an Optical Exposure Computer to be

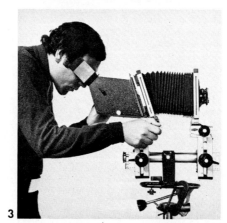

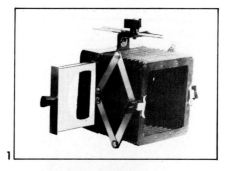

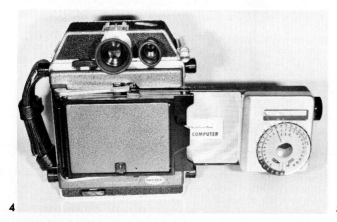

inserted into the spring back of a press or view camera just like a film holder. This three-step CdS meter is available in models to fit 2¼x3¼ or 4x5 formats and measures the light projected by the camera lens at the film plane, resulting in an integrated exposure that retains both shadow and highlight detail.

As its measurement is made at the film plane, all calculations for bellows extension in close-up or copy work are eliminated and compensation for exposure differences caused by the use of extreme swings and tilts is automatic. The old hand at view camera use may swear by his hand-held meter and an eyeball, but Calumet's EOC unit will deliver every time and with no excuses.

With the exceptions of film and filters, which we'll consider next, this should complete the basic equipment required by the beginning architectural photographer. Think over your needs well, compare models carefully and don't overlook the possibility of saving money by buying used equipment and you should be able to put together your set at a reasonable cost. ♜

1. *Bellows sunshade like that offered by Calumet accepts gel or glass filters in holder shown and can be adjusted for special effects or to prevent interference with use of camera swings and tilts.*

2. *Suspended by double rail attached to camera, Calumet sunshade slides to allow quick and easy access to lens.*

3. *Sinar Binocular Reflex Magnifier can be necksaver when shooting detail shots that require low or unusual angles. Upright ground-glass image is magnified 2X and its light-tight hood shuts out stray light that would destroy image brightness.*

4. *Calumet Optical Exposure Computer fits into place like a film holder, with all operating controls on right side of camera.*

5. *Roll film holders like Calumet C-2 handle both 120 and 220 rolls. Film is tracked by edges in this one and emulsion is never touched.*

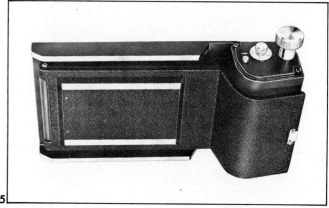

View Camera Buyer's Guide

If you're one of the approximately 12,000 photographers in the market for a new view camera this year, we'd like to take you on a guided tour through the maze of bellowsland. While it probably does not seem possible that there could really be much difference between view camera A and view camera B, you're in for a surprise once you investigate the rather limited number available. Actually, it's far easier for the novice to select a 35mm camera from the dozens available—as they're all essentially alike, it's not too difficult to pick one that will meet his needs.

But as simple as the concept of a view camera is—front and rear standards connected by a bellows—there's a great divergence in what you'll get for your money. And unless you live in a major city or near a large photo supply house that caters to the professional, the chances of finding a dealer that stocks sufficient models, sizes or brands of view cameras to make a meaningful comparison are slender. So come along as we try to provide a basic insight into what has become a rather bewildering world for the first-time view camera owner in recent years.

To get the most for your money, you should have a basic understanding of what's available and the differences you'll encounter in trying to make a selection that will meet your needs. Basically, there are two different types of view camera design—the traditional and the systems approach.

1. Three of many combinations possible with modular camera design are shown in series of Sinar view cameras, featuring unique asymmetrical tilt system that allows considerable flexibility in use of these cameras.

2. With camera movements on base (A), use of swings and tilts can shift image on ground glass, requiring additional camera work to reposition center of interest. When tilts and swings rotate about optical axis as in B, this is less likely to occur. Image will remain centered despite use of corrective movements unless tilt axis does not correspond with optical axis in a particular setup.

3. Modular construction characterizes modern view camera design. Flexibility inherent in systems approach provides numerous advantages but does not come cheaply; you can spend a great deal of money to create your own "design" for view camera.

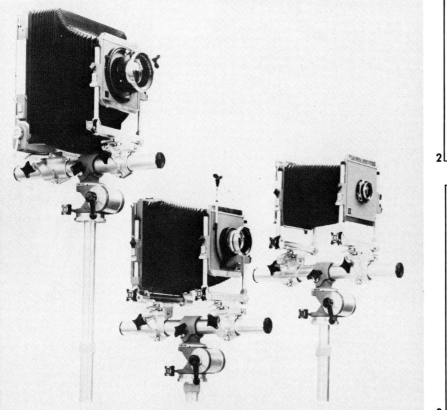

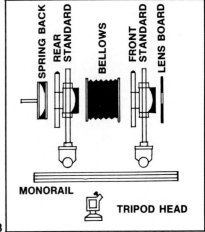

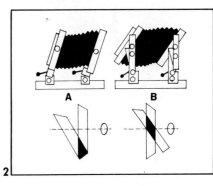

Buyer's Guide

The Deardorff, Calumet and Baco are examples of the traditional—the camera is a fixed unit possessing a specified amount of corrective ability in any given direction. The negative image size is dependent upon the lens used and the amount of bellows extension inherent in the design. Generally speaking, any view camera of this type has sufficient corrective capabilities to handle 98 percent of the architectural work you're likely to encounter in your career.

But a new approach to view camera design has appeared in the past decade or so, best exemplified by the Sinar, Super Cambo and Arca-Swiss, all of which are, incidentally, of foreign manufacture. This type of view camera is designed around the modular systems concept; by adding an extension to the monorail and changing the back standard, it's possible to convert a 4x5 into a 5x7 or even an 8x10. Ultra-close-ups without the apparent perspective distortion of short focal-length lenses can be obtained by adding an extension bellows and monorail extension to the basic unit. If the need for a wide-angle view camera arises, you can change over to a wide-angle bellows and if necessary, the traditional recessed lens board. In short, you can practically create your own view camera for any given need by adding or subtracting the interchangeable components, provided of course that your pocketbook doesn't go flat along the way.

There's a certain irresistibility about the modular concept because it makes so much sense, but we doubt if any beginning architectural photographer is going to become that deeply immersed in those unusual applications where the modular approach is of sufficient benefit to justify the investment. Where the modular view camera would come in handy is in

ARCA-SWISS SL-23A and SL-45A

Specifications

Format:	23A, 2¼x3¼''; 45A, 4x5''.
Construction:	Precision machined metal.
Vertical Swing:	Not specified.
Horizontal Swing:	2½'' front and back.
Rising/Falling Front:	2¼''.
Bellows Extension:	23A, 11''; 45A, 15⅞''.
Weight:	23A, 3.3 lbs.; 45A, 5.3 lbs.
Other Features:	Lightweight models differing from standard series only in that lens boards are smaller and extension coupling bracket is eliminated. All tilts and swings on optical axis, same cameras with base corrections are available and designated as SL-23B and SL-45B.
Price:	23A, $430 23B, $380 45A, $480 45B, $430
Distributor:	Bogen Photo Corp., 100 S. Van Brunt Street, Englewood, New Jersey 07631.

ARCA-SWISS SERIES I

Specifications

Format:	4x5 or 5x7''.
Construction:	Precision machined metal.
Vertical Swing:	Not specified.
Horizontal Swing:	4x5, 5'' front and back; 5x7, 5'' front and 7'' back.
Rising/Falling Front:	4x5, 3 3/16''; 5x7, 3⅛''.
Bellows Extension:	4x5, 15⅞''; 5x7, 17¾''.
Weight:	4x5, 6.9 lbs.; 5x7, 8.4 lbs.
Other Features:	All movements front and back are on the camera base. Accepts wide-angle bellows, extension bellows, sliding and reducing backs, etc.
Price:	4x5, $500 5x7, $585
Distributor:	Bogen Photo Corp., 100 S. Van Brunt Street, Englewood, New Jersey 07631

those situations requiring one camera to function as both a studio and field camera—where an equal or larger proportion of photographic assignments are outside the realm of architectural work and are varied in nature, such as product illustration, general commercial photography, portrait and industrial work.

The reader should not entertain the idea that we are opposed to the modular approach; we really find it a very flexible system with which to work, but as you must learn to crawl before walking, we feel that a traditional (and less expensive) view camera will suffice initially; once you have learned the fundamentals of the trade and have expanded your professional horizons, then perhaps the modular camera would also expand your capabilities. But for the beginner, it's a little like deciding that it might be "fun" to take up the hobby of photography and then buying the most sophisticated, automated and expensive camera on the dealer's shelf—one whose capabilities will probably never be fully utilized by our "hobbyist." In the same way, the beginner moving into architectural photography will find that the traditional design provides sufficient flexibility and room for growth while conserving that most important asset—money.

But much more important to the potential view camera user is the question of camera movements and how they're made. Here again, there are two systems in use; movements on the optical axis or on camera base. Each has its own advantages, and after carefully weighing the pros and cons against price considerations and what you can afford to pay, you'll have to decide which you feel is best for you. Briefly, the case for optical axis movements is based on the fact that the need for refocusing is minimized when tilting the lens to vary depth of field, or when moving

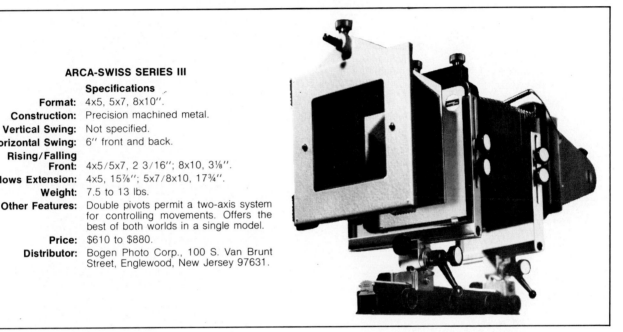

ARCA-SWISS SERIES III
Specifications

Format:	4x5, 5x7, 8x10".
Construction:	Precision machined metal.
Vertical Swing:	Not specified.
Horizontal Swing:	6" front and back.
Rising/Falling Front:	4x5/5x7, 2 3/16"; 8x10, 3⅛".
Bellows Extension:	4x5, 15⅞"; 5x7/8x10, 17¾".
Weight:	7.5 to 13 lbs.
Other Features:	Double pivots permit a two-axis system for controlling movements. Offers the best of both worlds in a single model.
Price:	$610 to $880.
Distributor:	Bogen Photo Corp., 100 S. Van Brunt Street, Englewood, New Jersey 97631.

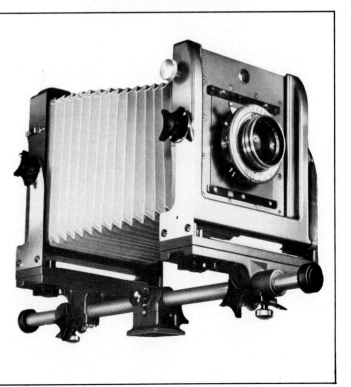

CALUMET CC-400, CC-401, CC-402
Specifications

Format:	4x5".
Construction:	Die cast aluminum alloy, stainless steel fittings, chrome steel working parts.
Finish:	Light gray body, gray bellows.
Vertical Swing:	Unlimited, front and back.
Horizontal Swing:	12° front and back.
Rising/Falling Front:	3" up, 1" down.
Horizontal Slide:	⅞" front and back.
Revolving Back:	360°.
Bellows Extension:	CC-400, 16"; CC-401, 22"; CE-402, 7 3/16".
Weight:	8¼ to 8¾ lbs.
Other Features:	All swings on pivot axis, adjustable tripod block, quick-release lever on front and rear focusing, 4x4" lens board furnished with camera, horizontal and vertical spirit levels, focusing cloth clips. CC-402 is wide-angle version.
Price:	CC-400, $114.95
	CC-401, $139.95
	CC-402, $154.50
Manufacturer:	Calumet Photographic, Inc., 1590 Touhy Avenue, Elk Grove Village, Illinois 60007.

the camera back to correct distortion. But this is true only under certain conditions—as when the optical axis coincides with the point of major interest for which you are focusing, or when both lens and camera back are actually tilted around their nodal points. In actual use, such conditions do not always occur, especially when using recessed lens boards or when the tilting axis does not correspond with the optical center of the lens.

Movements pivoted at the camera base offer the same degree of rigidity but with lighter camera weight. They also cause less interference with film holders when tilting movements are at an extreme and allow the use of shorter focal-length lenses without having to resort to recessed lens boards which inhibit the degree of swings and tilts that can be used.

The optical axis system also traditionally has been a center tilt and swing movement, but a few years back the Swiss Sinar-p was designed around a concept known as asymmetrical tilt. This is a method of using the camera's lens to calculate angles and distances in a manner to allow swings and tilts to be preset with almost complete accuracy. You select a point along the dotted tilt axis marked on the ground glass and focus that image point for maximum sharpness. Choose a second point off the tilt axis and turn another knob to

CALUMET C-1
Specifications

Format:	8x10''
Construction:	Metal castings with stainless side plates, chrome steel operating parts, chrome steel working parts.
Finish:	Metallic turquoise baked enamel body, black bellows with matte black non-reflective interior surfaces.
Vertical Swing:	Unlimited on front, 30° on back. Both on optical axis.
Horizontal Swing:	Unlimited on front, 30° on back. Both on optical axis.
Rising/Falling Front:	Lens board adjustment, 5''. With back vertical and full downward angle added to lens board adjustment, more than 9'' of displacement can be obtained.
Horizontal Slide:	4'' front, and rear.
Bellows Extension:	34''.
Weight:	14 lbs.
Other Features:	Extra-large focusing knobs with locks, adjustable tripod block with American and European sockets, wire focusing cloth frame, focusing cloth clips, horizontal and vertical spirit levels, standard 6x6'' lens board, double extension focusing track.
Price:	$395.
Manufacturer:	Calumet Photographic, Inc., 1590 Touhy Avenue, Elk Grove Village, Illinois 60007.

DEARDORFF PRECISION VIEW
Specifications

Format:	Available in 4x5, 5x7, 8x10 and 11x14 sizes.
Construction:	Wood with nickel plated brass, steel and aluminum fittings.
Finish:	Mahogany.
Vertical Swing:	Not specified.
Horizontal Swing:	Not specified.
Rising/Falling Front:	4x5, 4⅜''; 5x7, 4⅜''; 8x10, 6½''; 11x14, 9¾''.
Horizontal Slide:	Not specified.
Revolving Back:	360°.
Bellows Extension:	4x5/5x7, 22''; 8x10, 30''; 11x14, 42''
Weight:	7, 12½, 27 lbs.
Other Features:	4x5 available with Graflok fittings.
Price:	$515 to $1273.50.
Manufacturer:	L. F. Deardorff & Sons, Inc., 11 S. Des Plaines Street, Chicago, Illinois 60606.

get the image sharp at that point as well, then set the front standard to the degree of tilt marked on the scale, which also tells you the proper lens opening necessary for sufficient depth of field to bring both near and far points into critical focus. This "two-point focusing system" takes a lot of guesswork and trial-and-error motion out of camera movements, but it doesn't come inexpensively.

While you might imagine that the modular metal camera would be considerably lighter to carry around than a wooden one with its brass fittings, this is not necessarily true for the 4x5 format; despite their construction, 4x5 view cameras tend to weigh about the same. But the difference is noted in the larger formats and when you get into the 8x10 or 11x14 sizes, you're talking about a 50 percent reduction in weight, with the metal camera a distinct joy to carry by the end of a long day's shooting session.

With these basic considerations out of the way, you're now free to delve into the world of view cameras and on these pages, we've rounded up some of the current crop, along with specifications as provided by their manufacturers. The prices listed were those in effect when we went to print, but in today's inflationary marketplace, you can expect that they'll continue to be revised upward. So choose your swings and tilts and let's get on with the specifics of architectural photography.

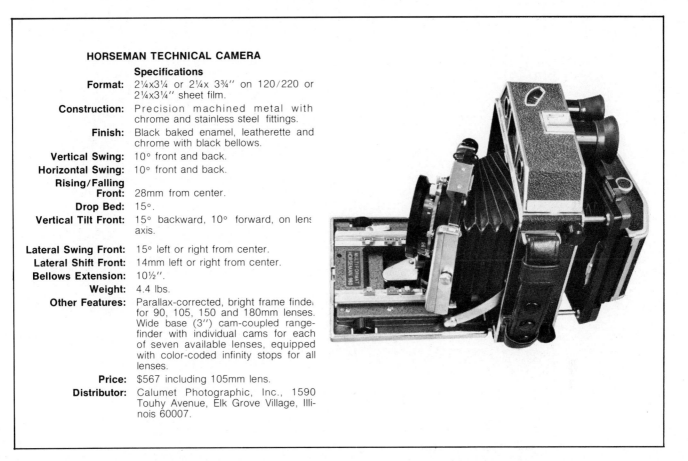

HORSEMAN TECHNICAL CAMERA
Specifications

Format:	2¼x3¼ or 2¼x 3¾" on 120/220 or 2¼x3¼" sheet film.
Construction:	Precision machined metal with chrome and stainless steel fittings.
Finish:	Black baked enamel, leatherette and chrome with black bellows.
Vertical Swing:	10° front and back.
Horizontal Swing:	10° front and back.
Rising/Falling Front:	28mm from center.
Drop Bed:	15°.
Vertical Tilt Front:	15° backward, 10° forward, on lens axis.
Lateral Swing Front:	15° left or right from center.
Lateral Shift Front:	14mm left or right from center.
Bellows Extension:	10½".
Weight:	4.4 lbs.
Other Features:	Parallax-corrected, bright frame finder for 90, 105, 150 and 180mm lenses. Wide base (3") cam-coupled rangefinder with individual cams for each of seven available lenses, equipped with color-coded infinity stops for all lenses.
Price:	$567 including 105mm lens.
Distributor:	Calumet Photographic, Inc., 1590 Touhy Avenue, Elk Grove Village, Illinois 60007.

SINAR-f
Specifications

Format:	4x5, 5x7, 8x10".
Construction:	Precision machined metal.
Finish:	Gray enamel and chrome, black bellows.
Vertical Swing:	40° front and back.
Horizontal Swing:	50°.
Rising/Falling Front:	3".
Tilt:	40° front and back.
Bellows Extension:	12" (18" extension available)
Weight:	6½ lbs.
Other Features:	Long focusing base, twin spirit levels, Graphic-type spring back, monorail construction, modular design. This basic Sinar model can be converted to a c or p model by interchanging modular units. Utilizes new two-point focusing technique (see text).
Price:	$395.
Distributor:	PTP Inc., 623 Stewart Avenue, Garden City, New York 11530.

Films and Filters

Films and filters—these are the tools that the architectural photographer uses to reproduce his subject matter; the choice of tools and how they're to be used determines to a large extent what the final picture will look like. More than any other field in photography, architectural work demands that the photographer have a thorough working knowledge of how each type of film he uses will affect subject rendition and how mood interpretation is gained and exploited (if desired) through the selection of film/filter combinations.

Such knowledge can only be gained by actually working with the films in question and while we could tell the reader to simply use Hyper-Sensitive Pan-X film and let it go at that, we would urge you to take the time (and spend the money) to experiment with a wide variety of emulsions and filters in order to form a working knowledge that will help you to evaluate an assignment in terms of several different combinations and their probable results. There are, however, a few general hints that we can pass along to get you started.

While most films can be used in a large number of different situations, there's usually one or two that are better suited for particular applications. Every film emulsion possesses certain photographic properties—a characteristic curve, color sensitivity, definition, speed and latitude—and each of these five factors must be considered when choosing a film.

THE CHARACTERISTIC CURVE

While it looks like a real mystery to many amateur photographers, a characteristic curve is nothing more complex than a graphical way of plotting how a particular film will respond to exposure and development. To obtain the curve of an emulsion in question, it's exposed in predetermined steps under carefully controlled conditions and then developed. The result is a gray scale with a number of steps that differ in density. The amount of exposure and the resulting density of each step are used to produce data necessary to plot the characteristic curve.

The slope of a characteristic curve indicates to the user how quickly density will change with changes in exposure. Each curve is divided into three sections—the toe, the straight line and the shoulder. Understanding the relationship between these three sections will help you in choosing the correct emulsion for a given photographic problem. In the toe or lower part of the curve, the separation of thin shadow densities becomes progressively less as the end of the toe is reached. As shadow detail and some of the lower mid-tones of the subject are usually recorded on the toe of a correctly exposed negative, you'll want an emulsion for architectural work with a considerable amount of toe to its curve.

The upper end or shoulder of the curve approaches that point at which differences in exposure are no longer recorded as differences in density. Translated into everyday English, this simply means that highlights in a scene with a limited brightness range should not be recorded on the shoulder of the curve or they'll lack the separation necessary for good negative quality. As the range of contrast inherent in most architectural subjects is often considerable, you should select a film with little or no tendency to form its shoulder at densities normally found in continuous-tone photography.

COLOR SENSITIVITY

This term describes a film's response to the varying wavelengths found in the light spectrum. Silver bromide, which forms the primary element in light-sensitive emulsions, is affected only by the blue and ultraviolet end of the spectrum, but by adding certain dyes that will absorb other wave lengths, it's possible to extend the range of sensitivity through green and red into the infrared area of the spectrum. The color sensitivity of an emulsion is an important consideration for the architectural photographer, as it determines how a colored object will be reproduced in gray tones, as well as what filters can be used for special effects.

Emulsions sensitive only to the blue/ultraviolet waves reproduce greens and reds too darkly, while panchromatic films, which have a response similar to that of the human eye, record all colors in gray tones with a relative brightness similar to that seen by the eye. On the surface, it would seem to the casual observer that a panchromatic emulsion is a panchromatic emulsion, and that's it, but nothing could be more misleading. All panchromatic emulsions are not equally panchromatic, that is, not equally sensitive to green and red wave lengths. Just because you've had excellent results with Dupan X-Pan, don't expect the same results when using Treepan X-Pan film.

Filters can be used to alter or correct the relative brightness at which various colors are reproduced in black-and-white; the particular filter used depends upon the color sensitivity of the emulsion. Filters and their effects are something we'll delve into more deeply in a few moments.

Basically, there are four groups of sensitivity in film emulsions:

1. Blue-sensitive—Sensitive only to blue and ultraviolet; used for copy work, black-and-white positives and

1. Film selected can provide emphasis customer desires in picture. For this apartment, client wanted picture to show size and pattern, and normal exposure on panchromatic film served the purpose well.

2. Pan film used with Kodak Pola-Screen darkens sky and accentuates light bricks. Type of pan film used should not have excessive grain if enlargements of any size are to be made. Many architectural photographers prefer slow, fine-grain films since length of exposure is seldom an important factor.

1

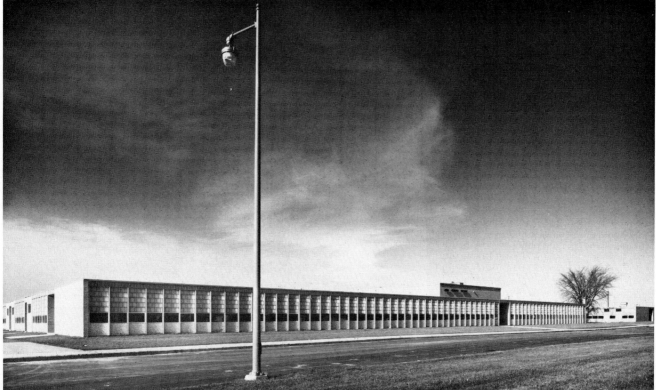

2

other uses where red/green sensitivity is not required. Can be loaded and processed under a red safelight.

2. Orthochromatic—Sensitivity range is expanded to include green; can be loaded and processed under a red safelight.

3. Panchromatic—Balanced color sensitivity to red, green, blue and ultraviolet, these emulsions should be handled only in total darkness.

4. Infrared—Sensitive to ultraviolet, blue, red and invisible infrared radiation, this emulsion has valuable applications for architectural photography and like pan films, should be handled only in total darkness. Never run any form of electrical device that throws off heat while working with infrared emulsions in the darkroom.

DEFINITION

Definition is a property of emulsions as well as of lens performance, and the term is used to describe the combined effects of grain, resolving power and acutance, or sharpness. Each emulsion possesses an inherent tendency toward grain, as the result of silver which clumps together and forms a granular pattern upon development. The degree of apparent grain is dependent upon exposure and development—giving a film more exposure and/or development than is absolutely necessary to produce a satisfactory negative will increase the apparent grain.

As the resolving power of an emulsion falls off considerably at both high and low exposure values, it follows that the best resolution is obtained at an intermediate point. Maximum resolution is limited by the camera lens, which should be capable of resolving power three times that of the emulsion being used.

Acutance is the ability of an emulsion to give good edge sharpness between differing densities that create detail in a print. When areas of high and low density border each other, the line between the two is not perfectly sharp, as the high-density area tends to intrude upon the lower density. The less intrusion present, the higher the acutance and the sharpness of the image.

SPEED

Each film emulsion is assigned a film speed or ASA number for use in computing exposure. ASA numbers are arithmetic in their indication of relative sensitivity to light, thus an ASA 50 emulsion will need twice as much exposure as one with an ASA of 100. The ASA number assigned an emulsion will provide the minimum exposure necessary to give a good negative, but by changing the conditions of exposure and development from those used to determine the rating initially, the film's effective speed can be altered. All manufacturers take care to point out that a film's assigned ASA rating is not a fixed point, but rather it should be used as a beginning guide in determining cor-

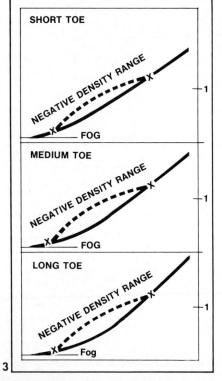

1

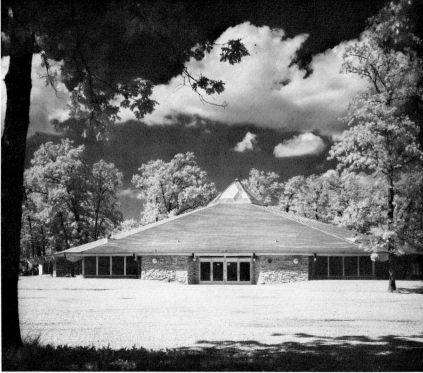

2

3

4

rect exposure according to individual working methods and equipment.

LATITUDE

You'll get your best negative when the emulsion receives the minimum exposure necessary to record shadow detail adequately. An emulsion's latitude is the range of deviation possible from the ideal point that will still produce a satisfactory negative. Latitude then is a reserve power within which adequate performance can be achieved, but whenever this reserve is brought into play, the results will be less than optimum as deviations from the ideal in exposure and development in turn affect negative density, grain, acutance, etc. adversely.

In architectural work, the useful exposure range of an emulsion is not constant but instead varies with the subject's brightness range. When photographing contrasty subjects, you'll have less exposure latitude to fall back on than with flat subjects having no important shadow areas that must be reproduced.

FILTERS

It can thus be seen that film selection is a far more complex task than simply picking one emulsion and sticking by it through thick and thin—so too is filter choice. As we mentioned earlier, the choice of possible filters that can be used with a given film depends upon the emulsion's color sensitivity.

In black-and-white photography, filters are generally used for correction or contrast, although a large variety of filters are available for special purposes such as haze reduction, infrared photography, exposure reduction and the like. Certain panchromatic emulsions have a higher degree of sensitivity to blue and ultraviolet, while others possess a predisposition toward the red end of the spectrum. In either case, the excessive sensitivity results in a photographic effect unlike that seen by the eye and so correction is necessary. A common example of this is the blue sky with white clouds which photographs far too light for visual distinction of the cloud formations. Contrast filters produce a brightness difference between two colors that would otherwise reproduce as equal tones of gray in black-and-white photography.

As a rule of thumb, the gray tone rendition of a particular color is darkened by using a filter of a color complementary to the one in question—the yellow filter would darken our blue sky and reveal the missing white

1. Infrared film with F filter turns clouds, trees and grass white while blackening sky. Photographers inexperienced in use of infrared material should make test exposures to learn how to anticipate its exposure requirements for tonal renditions. Unexpected color and tonal values of construction materials can cause problems for the inexperienced.

2. Typical characteristic curve shows relationship between exposure and density as plotted by sensitometry.

3. Adapted from Kodak's Professional Data Book F-5, this drawing illustrates typical different curves.

4. Infrared film with G filter gives results that are not quite as contrasty as with F filter. When there is large amount of foliage, it may well be a better choice.

TABLE I—BLACK & WHITE SHEET FILM

Name	Type	ASA Index D/T	Characteristics
AGFA-GEVAERT, INC.			
Agfapan 100	Pan	100/100	Medium speed, extremely fine grain.
Agfapan 200	Pan	200/200	Moderately high speed, very fine grain.
Agfapan 400	Pan	400/400	Fast speed, fine grain.
GAF CORP.			
Commercial Ortho	Ortho	50/25	Fine grain, all-purpose.
Finopan Gafstar	Pan	64/—	Finest grain, low speed.
Versapan Gafstar	Pan	125/—	Fine grain, medium speed, moderate contrast.
Superpan Gafstar	Pan	250/—	Fine grain, moderately high speed.
Super Hypan	Pan	500/—	Extremely high speed, all-purpose available light emulsion.
Vivapan A	Pan	80/—	Very fine grain, moderate speed, high acutance.
ILFORD			
Ilford SP-124	Pan	125/100	Has specially treated surface for retouching.
Ilford FP4	Pan	125/100	Medium speed, fine grain, moderate contrast.
Ilford HP4	Pan	400/320	Very fast, moderate fine grain.
EASTMAN KODAK			
Kodak Professional Copy 4125	Ortho	25/12	Increased highlight contrast for continuous-tone copying and photogravure work.
Kodak Commercial 6127	Blue-Sen.	50/16	Medium speed, high contrast, for continuous tone copy work
Kodak Contrast Process Ortho 4154	Ortho	100/50	High contrast for copying b&w originals.
Kodak Contrast Process Pan 4155	Pan	100/80	Medium speed, high contrast for copying colored line originals.
Kodak Ektapan 4162	Pan	100/100	Medium speed, both sides suitable for retouching.
Kodak Plus-X Pan Pro 4147	Pan	125/125	Medium speed, very fine grain, high sharpness, all-purpose.
Kodak Super-XX Pan 4142	Pan	200/200	Moderately high speed, all-purpose, for color separation negatives and b&w negatives from color.
Kodak Super Panchro-Press 6146	Pan	250/250	Fairly high speed, all-purpose, both sides suitable for retouching.
Kodak Tri-X Ortho 4163	Ortho	320/320	Very fine grain, moderate contrast, both sides suitable for retouching.
Kodak Tri-X Pan 4164	Pan	320/320	Good latitude, contrast control, has excellent gradation characteristics
Kodak Royal Pan 4141	Pan	400/400	Fast, fine grain, wide latitude, both sides suitable for retouching.
Kodak Royal-X Pan 4166	Pan	1250/1250	Extremely fast, medium grain, available light work.
Kodak High Speed Infrared 4143	IR	80/200	High speed, moderately high contrast special applications.
SUPREME PHOTO			
Imperial "S"	Pan	400/125	Fast, fine grain, good latitude.

Films and Filters

clouds. If you use a filter of the same color as that in question, you'll lighten the tonal rendition—a green filter lightens green foliage.

An increase in exposure equal to the proportion of light absorbed must be made when using a filter. Each filter thus has a factor by which the exposure should be increased to retain normal negative density—a factor of 2 means increase exposure by one f/stop (double the exposure), a factor of 4 means increase exposure two stops (four times the exposure), etc.

SPECIAL APPLICATIONS AND FILTERS

As atmosphereic haze scatters the blue and ultraviolet light waves, it can be reduced or eliminated by using a filter that absorbs blue and UV rays. Such filters will not affect the rendition of visible colors. A contrast blue filter is used to introduce a haze or fog-like effect for special effects, while polarizing filters will eliminate glare and surface reflections, thus deepening tonal renditions in black-and-white photography and color renditions in color work. When using infrared emulsions (which are also sensitive to blue and violet), it's necessary to remove the unwanted visible waves by filtering them out before they reach the film. And if the intensity of light is too great to permit use of the desired shutter speed/lens opening combination, it's desirable to reduce the illumination without altering the tonal renditions by using a neutral density filter.

BASIC FILTERS FOR ARCHITECTURAL WORK

Filter selection and their use merits an entire book in its own right, especially if you're dealing with color films and the large number and possible combinations of color correction, light-balancing and conversion filters available. We have neither the time nor the space here for an exhaustive study of filters, but would recommend that those beginning in architectural photography acquire at least the following six filters as a minimum starting point for black-and-white work, yet experimentation with other filters should not be ruled out. You'll find these filters most useful:

1

2

3

1. **Light yellow**—A good filter for general exterior work that strengthens shadows somewhat while deepening skies slightly.

2. **Medium yellow**—This will give the correct visual rendition of most subjects when used, with panchromatic emulsions, but may cause a loss of detail when used where deep shadows are present.

3. **Light green**—Has approximately the same correction value as the medium yellow filter, but darkens red slightly and lightens green somewhat, making it ideal for use where foliage is prominent.

4. **Orange**—Provides a strong contrast when used with exterior subjects and can prove useful in situations where correction is desired, such as

1. Pan film with G filter improves contrast in sky and for most masonry construction, but not as dramatically as infrared film does.

2. Drama of infrared makes this rather ordinary church stand out. But picture also illustrates problem with infrared film and/or dark filters—while the heavy shadows make arch stand out, roof almost merges with sky. If this picture were cropped leaving off left quarter of frame, it would be improved considerably.

3. Pan film with A filter produces results similar to infrared here. Some photographers prefer pan film with series of filters over infrared as pan film can provide variety of effects without exposure problems.

TABLE II—BLACK & WHITE ROLL FILM

Name	Type	ASA Index D/T	Characteristics
ADOX			
Adox R14	Pan	20/16	Ultra fine grain, high resolution.
Adox R17	Pan	40/32	Ultra fine grain, high resolution.
Adox R21	Pan	100/80	Fast speed, ultra fine grain, high resolution.
FUJI			
Neopan SSS	Pan	200/—	Fast, fine grain, wide latitude.
GAF CORP.			
All-Weather Pan	Pan	125/—	Wide exposure latitude, general all-purpose emulsion.
Versapan	Pan	125/—	Medium speed, fine grain.
Super Hypan	Pan	500/—	Extremely high speed, all-purpose available light emulsion.
ILFORD			
Ilford FP4	Pan	125/100	Fast, fine grain, good latitude.
Ilford HP4	Pan	400/320	High speed, medium grain, good latitude
EASTMAN KODAK			
Kodak Panatomic-X	Pan	32/—	Extremely fine grain, excellent definition, allows great enlargement of negative.
Kodak Verichrome Pan	Pan	125/—	Wide exposure latitude, general all-purpose emulsion.
Kodak Plus-X Pan Professional	Pan	125/—	Very fine grain, medium speed, excellent sharpness.
Kodak Tri-X Pan Professional	Pan	320/—	Fast, general purpose excellent gradation, brilliant highlights.
Kodak Tri-X	Pan	320/—	Fast, general purpose.
Kodak Royal-X Pan	Pan	1250/—	Extremely fast, medium grain, available light situations.
SUPREME PHOTO			
Imperiale Pan 120	Pan	400/125	High speed, fine grain.

Films and Filters

photographing multi-colored brick buildings.

5. Red—Uses of this filter are specific and should be clearly understood or the resulting pictures will border on the bizarre. A red filter should be used with infrared emulsions to prevent the visible light rays from reaching the film.

6. Polarizing—Deepens colors, eliminates glare and surface reflections, penetrates haze without diluting colors.

GLASS OR GELS?

Photographic filters are available in three basic types; solid optical glass, laminated glass and gelatin. Glass filters are the most durable, and have the highest degree of stability against changes in transmission characteristics, but it's difficult to obtain the same precise coloration in glass that's available in gelatin filters or gels, as they're commonly called.

Cost is also a factor here as the large sizes of glass filters required for use with view camera lenses are very expensive.

Laminated filters consist of gels laminated between two pieces of optical glass, or two pieces of glass bonded together by a cement containing the filter dye. While these combine the best features of optical glass and gels, they're not as popular today as they were in the past and in most cases, are almost as expensive as solid glass filters.

You'll find the most complete line of filters available in gel form. These are the thinnest (about 0.1mm), the most precisely colored and the least expensive, but they require considerable care in handling and use. As

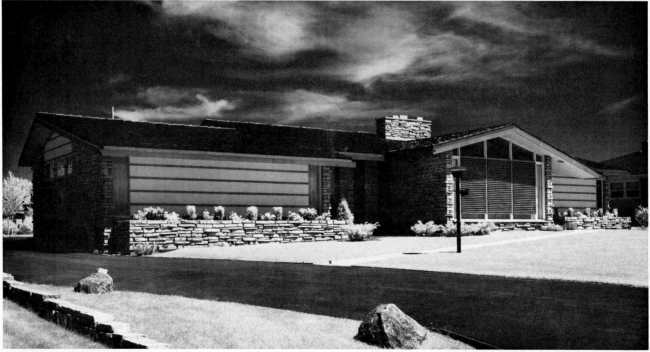

1

2

3

1. While castle may be small one, the drama can be just as great with right choice of film/filter. These two pictures of rather typical ranch-style house would help make realtor's catalog a work of art rather than usual poorly exposed Polaroid snapshot. Actually, expense is not much greater. Taken on infrared film and enlarged as straight prints with no darkroom magic, these pictures also illustrate lesson in composition. Note how depth added by tree improves shot at top and then check to see differences in tonal rendition brought about by moving camera position while lighting remains the same.

2. Self-sealing filter frame is the ideal method of handling gelatin filters. Space is provided for writing in filter type and its factor. Calumet filter frames have backing paper that peels off exposing special adhesive to hold gelatin filter.

3. Bellows-type sunshade such as this provided by Calumet accepts either glass or gelatin filters in its filter holder.

4. Selecting the right location and adding a bit of darkroom technique can produce this result. By burning-in foreground, stone of house stands out. Yellow filter added contrast.

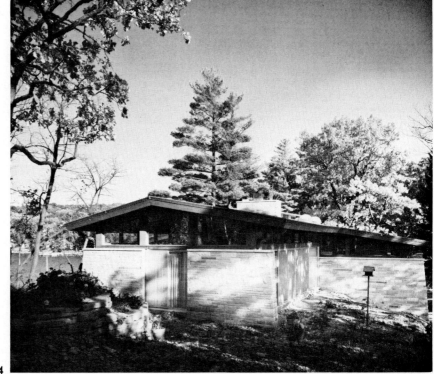

4

gels are protected only by a thin lacquer coating, they scratch easily, collect dust and are prone to deformities caused by heat, moisture and stress, but they do possess excellent optical qualities and have little effect on definition of the photograph.

Gels are also the most practical for the architectural photographer to work with. Available in 2-, 3-, 4- and 5-inch squares, they're inexpensive enough to be replaced periodically and one size can be used with an entire complement of lenses from wide angle to long focus, especially if you use them in a gel filter frame. They should be handled by the edges or extreme corners only and stored flat in their original packages and in a dark, dry place when not in use.

HANDLING SHEET FILM

If you've never worked with a press/view camera before, you'll have to learn to load your own film holders. Sheet film comes in a box with black paper interleaving between each sheet and must be transferred to a film holder in total darkness—unless you're using an ortho emulsion, when loading by a red safelight is permissible.

Each sheet of film has a notch or group of notches on one edge which identifies that particular emulsion. When the sheet is held so that the notch is at the top right edge, the emulsion side of the sheet is facing you. You should learn the notch codes of the films used most often to prevent the hazard of loading film A when you think you're loading film B.

The dark slides of sheet film holders have a bright and a dark side at their binding faces to indicate unexposed/exposed film and most use a notch or raised dot on the bright side for identification in the dark. When loading holders, the dark slides should be removed and placed standing up against a wall with the bright side facing you. The holder is then set in front of the dark slides. Arrange all holders to be loaded in

Films and Filters

this manner, check the film box label to be sure you've got the right one, then turn off the lights.

Pick up a sheet by its notched edge with a thumb and finger and check the notches to make sure it's the emulsion it's supposed to be. Then open and hold the holder flap with your left index finger and insert the film (emulsion side facing you) under the retainer channel on one side. Guide the other film edge under the opposite channel, slide your right index finger to the center of the sheet and push the film into place until it seats beneath the retainer at the end of the holder. Fold the flap closed and insert a dark slide with its bright side out, then turn the hook on the holder top to prevent an accidental withdrawal of the slide.

Loading film in this manner is a breeze but if you try to hurry the process, you may run into trouble; if you encounter resistance, withdraw the sheet and try again. But be careful—bending, kinking or pushing hard on the sheet can easily cause a mark on it that will ruin the negative. So be prepared to spend a bit of time and go slowly until you've become entirely familiar with the procedure; you should be able to load six holders (12 sheets) in about 20 minutes.

If you plan on loading more than one type of film during a single session, make it a split-session. Load all required sheets of one type, turn on the lights and set up for the second type, then load. If you have more than one box of film open at the same time, chances of an error are

1

2

3

1. For glass filter use, drawers are available with retaining rings to hold Series 8 and 9 glass filters.

2. Lisco Regal sheet film holders are choice of many professionals as they're rugged, thin and lightweight, three features you come to appreciate after long shooting session on location where lugging equipment takes as much time as actual photography.

3. Polaroid 545 Land Film Holder can be used with most press/view cameras and gives architectural photographer "picture-in-a-minute" capability in checking camera position and lighting for shot.

4. Bellows sunshade offers several advantages for architectural photographer. Besides swinging and tilting to prevent cut-off, it's excellent filter holder for glass of gels.

5. In this particular assignment, client was interested primarily in gold-grillwork, dark red brick and white cement. Using infrared film with F filter brings out brick detail but gold grillwork went white, almost same color as cement.

6. To overcome problem, Kodak Pan-atomic-X film was used with same F filter. It has totally different effect, but this combination separated gold grillwork from white cement while allowing brick detail to show.

good and you may well mix up the holders in the dark so that the pile of film holders loaded with film A actually has one or more with film B in them and vice versa.

When unloading exposed film from holders, it's best to transfer the film directly to hangers and develop it. If you don't plan on immediate development, put the exposed sheets into an empty film box, interleaf each sheet with black paper to prevent scratches and abrasions and label the box *exposed Type ZZZ film* in large letters, then seal each end to prevent inadvertent opening.

Before we send you out on assignment, one final word regarding films and filters. Use several different emulsions and try differing filter combinations. Keep records of your results and settle on one or two basic films as a starting point. When you do go on assignment, photograph the subject not with one film and one filter, but with several different emulsions. This will not only give you actual on-the-job experience with various films which will help you in the future, but you just may turn up a print from one of them that captivates the client's interest and that's what it's all about, isn't it? ♔

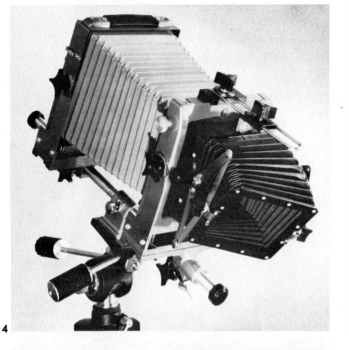

4

TABLE III—COLOR FILMS (Sheet & Roll)

Name	Type	Size	ASA Index D/T
AGFA-GEVAERT, INC.			
Agfachrome CT18	Positive	S	50/12
Agfacolor CNS	Negative	R	80/20
FUJI			
Fujicolor	Negative	R	100/—
GAF CORP.			
GAF 64	Positive	R	64/16
EASTMAN KODAK			
Ektachrome Daylight	Positive	S/R	50/NR
Ektachrome-X Daylight	Positive	R	64/16
High Speed Ektachrome Daylight	Positive	R	160/40
High Speed Ektachrome Tungsten	Positive	R	80/125
Ektacolor Professional Type L	Negative	S	64/64
Ektacolor Professional Type S	Negative	S/R	100/25
Kodacolor-X	Negative	R	80/20

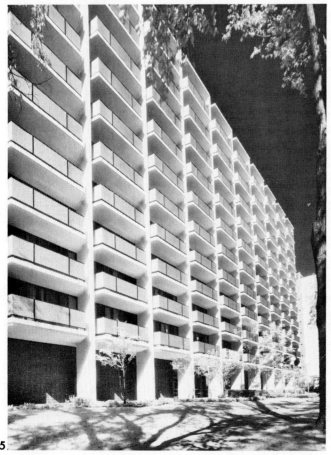

5

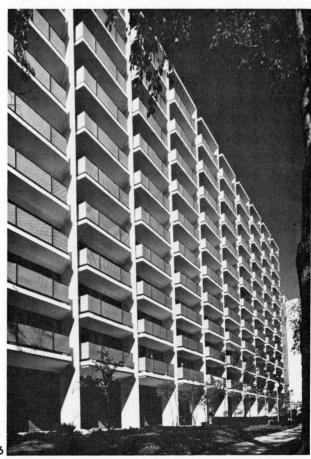

6

Architectural Photography and Exteriors

Despite the fact that architectural photography has many different and varied aspects, many people tend to regard it as but another field of endeavor well within the capabilities of the average photographer. Unfortunately, all too many pictures of buildings reflect this opinion exactly, lacking the combination of composition, balance of tone, lighting and technical knowledge that must be gained to take really good pictures of architectural subjects. But any professional who has photographed either the interiors or exteriors of buildings will confirm our contention that a good deal of specialized knowledge is required if you are to obtain those results that make a client willingly part with his money and invite you back the next time he has an assignment.

While you may be reading this simply as an exercise in improving your technique of photographing historic or modern architecture for your own pleasure, we think it unlikely that any reader would not like to capitalize on his hobby financially, and so our standards throughout the remaining pages will consistently be those of the professional who can accept an assignment and deliver both technical and artistic excellence, and we'll give you the basic knowledge to do just that. Certain art fundamentals are required in any photographic work and are especially important in architectural photography. Regardless of the film format, equipment or subject matter involved, the basic rules of composition exist and must be adhered to. In architecture, you'll most often be concerned with geometric design, closely followed by texture and tone.

Many of the buildings that the architectural photographer encounters may not be pleasing to him, but the same is true of art exhibits and galleries. Each person interprets what he sees in reference to his own personal likes, dislikes and background. While trying to turn out the most pleasing picture possible, the architectural photographer is frequently asked to produce a picture in a particular way required by the architect, builder or building owner. In such assignments, he should do his best to depict this aspect of the building without reference to his own personal opinions. Not too surprisingly, those photographic subjects which in themselves are not necessarily beautiful often prove to be the most interesting and challenging for the photographer.

Architects, suppliers of architectural materials and contractors are among the most critical photographic clients that exist today. Anyone attempting to sell his architectural pictures will quickly learn this and will also quickly learn that no matter how many years he's been a photographer, it will take him an additional three or four more to learn to take good architectural pictures. Not only is practice required, but the criticism of your work provided by customers or prospective customers is essential to your growth and development in the field. As you face each new assignment, it becomes not only a challenge to your skill as a photographer, but also of your skill in interpreting the instructions and desires of the customer for whom you're working. While this may at times seem frustrating, it's part of the fun and the adventure of taking good architectural photographs, which can be satisfying as well as a profitable sideline and/or full-time occupation.

Understandably, your keenest critic will be the architect and this is as it should be—he preconceived the finished work in his mind and put his all into the design. Your pictures will have to emphasize the strong points and best features of his design as he sees it, while at the same time minimizing whatever limitations the site, materials or workmanship may have imposed upon the end results.

Thus, to take good architectural photos, you should have at least a basic understanding of and some appreciation for architecture. The tools with which to work can be gained in these pages, but their application is up to the photographer and to do so properly, we recommend a program of self-study at the local library or a course of instruction at a nearby community college to acquaint yourself with the subject from the architect's point of view. Once you've accomplished this, you'll have everything you need right at your fingertips and can then function with confidence and satisfying results.

As you'll soon discover, architects are exacting, precise individuals and somewhat difficult to please, as their training in design and composition leads them to strong ideas and feelings about their work. Because of the widespread controversy about the environment and its interaction with man, architects have become leaders in a growing public concern about buildings, their setting, landscaping and surroundings that did not exist a half-century ago. What "right-minded" citizen of 1923 would recognize today's churches, much less accept them as such? As we've mentioned, the architectural photographer then has to be in tune with the major

1. Early morning shadows help make sign on end of YMCA building in Milwaukee stand out while adding to three-dimensional effect of side view. Pictures of public buildings can often be sold for postal cards.

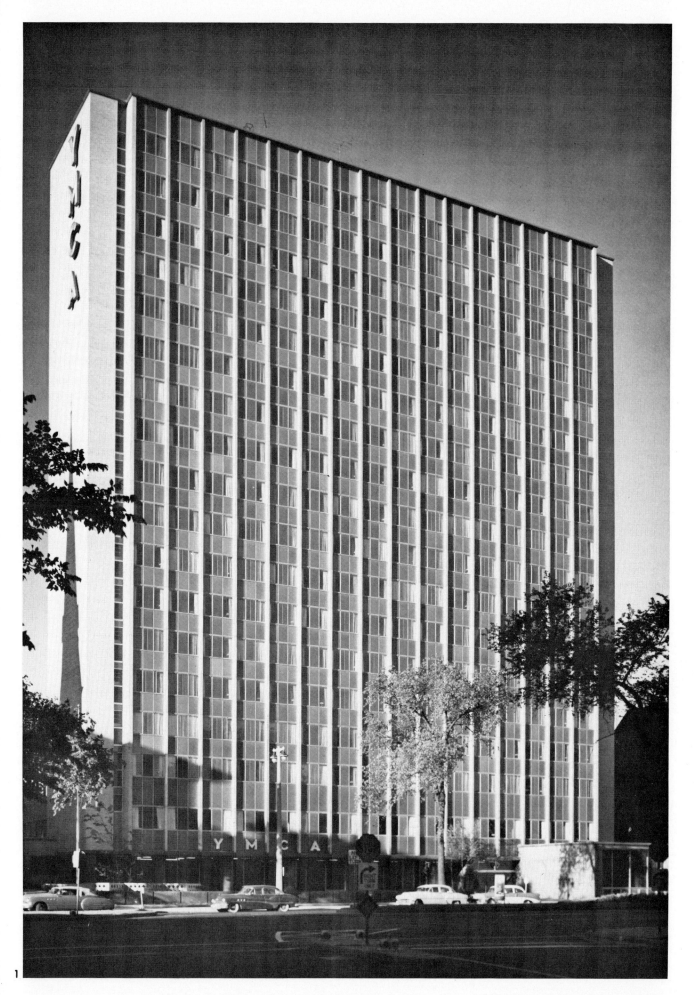

1

Exteriors

movements in both his and the architect's field—you don't have to *like* every subject you shoot, but you must *understand* them in order to recreate them properly on film.

The inability of many photographers to understand the thinking behind that which they are recording for posterity (and a healthy fee) accounts in large part for the mediocre photographs of buildings that one sees so often. By and large, they turn out to be dull pictures because of uninteresting lighting, indifference to pattern or surface texture, or just poorly selected angles. It becomes your task to overcome such faults if you wish to excel at the art, and to do so, you must first consider the big picture—and develop a point of view.

POINT OF VIEW

Point of view is nothing more than a determination of where to correctly place the camera for best results, and while it sounds elementary enough, many photographers have no coherent approach at all to selecting a camera position properly. While it may often seem desirable to choose a camera position directly in front of the subject, this point of view really should be avoided if at all possible, although you'll find it to be one which many architects especially like.

A friend of ours who makes his living practicing the art of architectural photography once photographed a new building whose outstanding feature was a huge curved window. Taking the pictures from directly in front of the window with the camera lens in line with its base, he managed to lose the entire uniqueness of the design as his choice of camera position completely flattened the window curvature, making it appear to be simply another large piece of glass. Choosing an oblique angle will produce a more pictorial effect and avoid the possibility of symmetry in the composition. While symmetry may be desirable under some circumstances, you'll find that its use tends to deaden many architectural subjects by producing a flat, poster-like effect.

Despite its seeming simplicity, the choice of a correct point of view is of primary importance, especially where the available working space is limited or the subject an unusual one never before encountered. Composition is dependent upon where the camera is placed, and pictorial balance depends on how the elements are arranged and composed. Both are functionally related to lighting, which is also determined by camera placement. So regardless of how you view the factors that contribute to a good architectural photograph, everything initially hinges on where you choose to plunk down the camera and say, "This is it!"

As camera position for exterior work is determined by these several factors working in combination, there will be many times when compromises are the only answer, since the best camera position for the lighting effect you need may not be the same as for composition. To reveal form, choose a position that provides frontal emphasis of the subject while also allowing one side to be seen. Under ideal circumstances, lighting will work in conjunction by emphasizing the front of the building while a shadow thus created on its side will assist in gaining the dimensional quality necessary for a good photograph.

A building facing to the east must be photographed in the morning if the sun is desired on its front. To include the needed shadow, the camera must be placed in a north-easterly direction

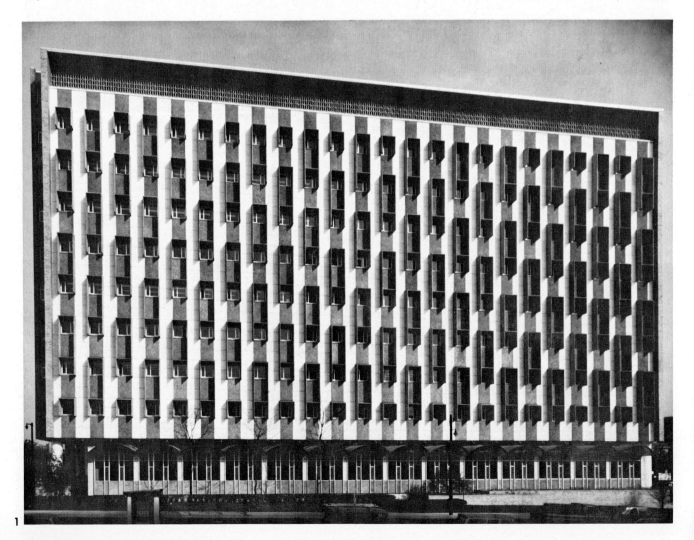

1

from the building. Remember that we're talking about the northern hemisphere here; if you're working below the equator, everything is reversed. Buildings facing to the south give the photographer the greatest flexibility in camera location, as they can be photographed during the morning from their left front and in the afternoon from the right front.

North-facing buildings are the toughest with which to work because if the sun doesn't give the desired effect in the early morning or late afternoon, you'll have to wait for a slightly overcast day when the lighting ratio is lower. Such soft light is also often desirable when working

1. Modern architects seem addicted to square and box shapes in building design. Straight-on side view, while it may not always be photographer's idea of best angle, usually pleases the client nonetheless.

2. This photo of building entrance was photographer's choice to show entrance to building. While more non-professional viewers prefer the photographer's choice, most builders like the other shot best.

3. This photo of building entrance was taken with one objective in mind: please the builder by showing construction of walkway cover.

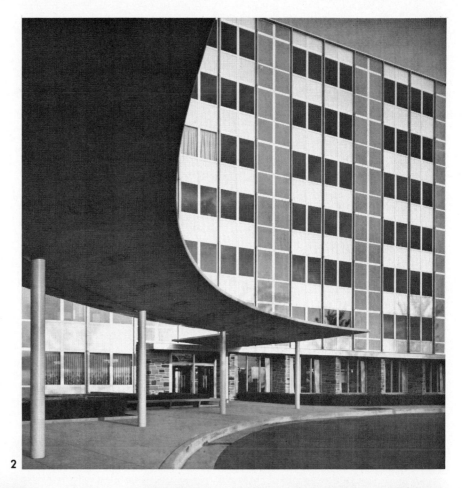

2

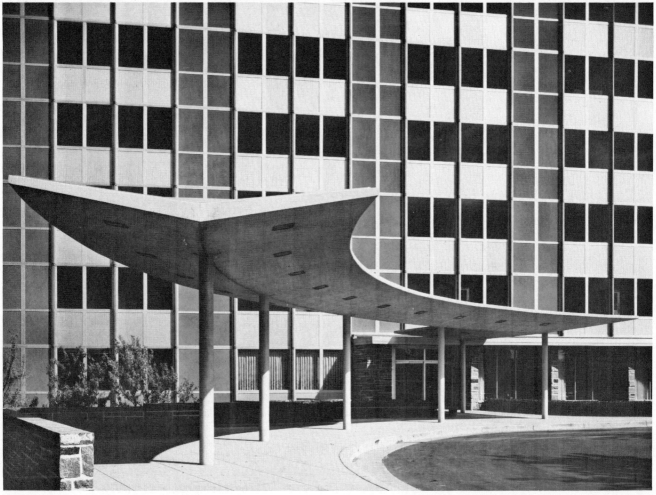

3

Exteriors

with buildings that have many surrounding trees, as direct sunlight will cast heavy, distracting shadows. A great help in determining when the lighting will be the best for your purposes is the use of a top-view sketch. Working it out on paper this way in advance of actual shooting will help you to select the right camera placement while anticipating the effects of the lighting.

One of the most difficult aspects of architectural photography lies in the degree of control over those objects that are unrelated to the primary in-

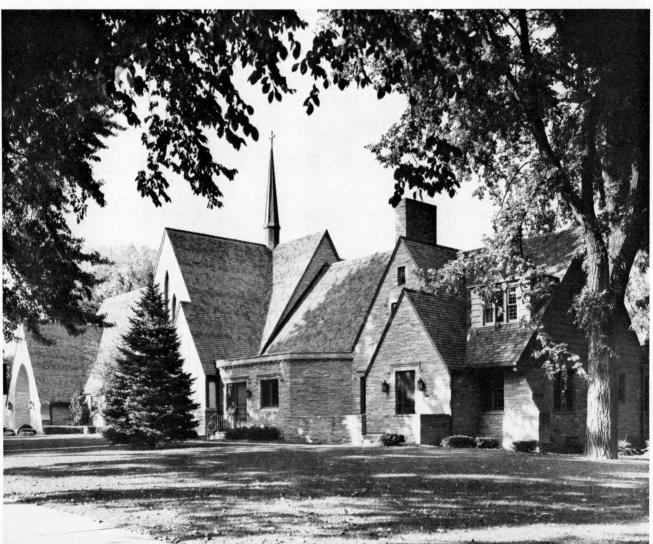

terest; no building is ever created with the same detachment present in the architect's original rendering. Trees, telephone poles and wires, street signs and signal lights, other buildings—these are but a few of the many distractions which plague the photographer in his quest for perfection, and as only a few of them can be removed in any given situation, the choice of point of view becomes all the more important.

If utility wires cannot be avoided in the picture, you should fight the human temptation to snip them in half and work them instead into the compositional structure of you picture. Should their inclusion still present a distraction despite what you do, pick up your tripod and search out another camera placement rather than surrender and turn out a mediocre picture. In some cases, such minor annoyances may be corrected by retouching, but don't fall victim to the impression that a good retouch job will save you regardless of what you do or don't do—it just can't be done that often and this kind of a crutch is a bad habit.

THE ILLUSION OF DIMENSION

All buildings are created as volume,

1. Making top-view sketch like this one will help you figure out lighting and camera position in advance and let you analyze the subject for best results.

2. House in this picture is always under strong shadows and little sunlight, presenting challenge to photographer. Infrared film actually serves to brighten normal appearance in this case. If subject were photographed on overcast day, heavy shade would create unacceptable contrast loss.

3. Buildings in heavy shade cause exposure problems that may not be overcome in relatively straight print. It's not as evident here that front of building with steeple is over-exposed (the halftone screen hides the fact), but if it were critical that the area be printed, a mask could have been made with litho film and opaquing medium to mask out all except area you wish to burn-in. Some photographers also take two exposures at exact same spot and strip the negatives together. Neither procedure is for average amateur, usually being performed by highly trained experts of pro printing firms.

4. Best time of day to take picture may never come, particularly when client wants it NOW. This bank's construction of glass and glossy metal facing makes a mass of reflections at any time of day or season. Photographer chose overcast day and used Kodak Pola-Screen with Kodak Pan-X film. Lens was 100-degree wide angle used with 4x5 camera. Because of close distance to building made possible by lens, negative had some convergence that was corrected in enlarger. Clouds were printed-in.

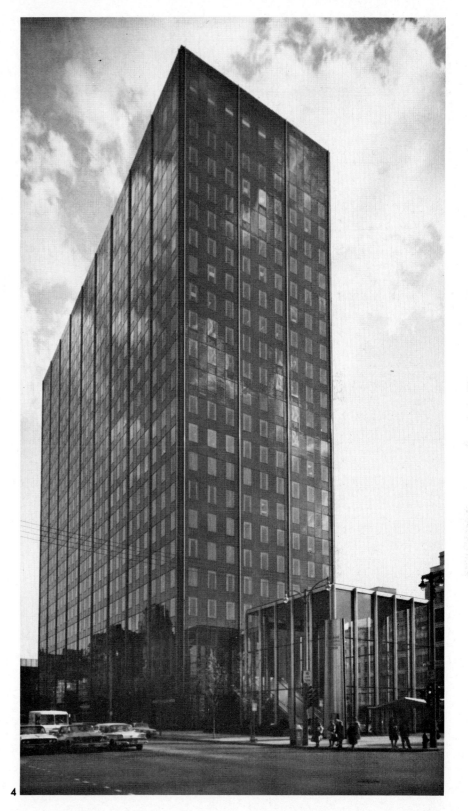

4

either by a solid form (whether simple or complex in design) or an association of forms. Thus the illusion of volume involves dimension and its suggestion, and as such, is a challenge to the imagination of the creative photographer in bringing a building to life. This illusion of dimension includes perspective and scale, two factors controlled by the choice of point of view and focal length of the lens used.

The distance between lens and subject controls the degree of perspective apparent in the picture regardless of lens' focal length or negative size. When a specified negative image size is considered, it's well to remember that longer focal-length lenses will produce flatter images, resulting in a telescoped sense of perspective, than do the shorter focal lengths. Objects of known sizes should be used as a reference point

Exteriors

for suggesting scale, if they fit into the composition of the overall picture. The association of these diverse elements combines with the tonal and textural values in determining the illusion of reality or stylization evident in the finished picture.

Fortunately, there are no rigid formal rules relating to the use of strong or weak perspective. There is a general rule of thumb which states that conservative subjects will appear more pleasing when weak to normal perspective is used, while much of what's considered to be modern architecture seems to best lend itself to the drama inherent in strong perspective. But although this may sound like a lifesaver for the beginner to grasp in sorting out the question of how to treat the subject, such a general rule is no substitute for a searching eye.

Strong perspective becomes more emphatic in three ways as the distance between your camera and subject diminishes. First, those parts of the building closest to the camera and those objects like trees in the same plane will appear to be overly large. Second, horizontal lines on the side and front of the building converge quickly. Third, sloping roofs take on a shallow appearance and may disappear completely under some circumstances.

You can decrease the convergence of horizontal lines by swinging the camera back, as we've seen, but any such decrease in those lines on the side of the building will result in an increase in the convergence on the front, and vice versa. As the building front usually holds more importance for the eye than the side, use the swing to effect an appropriate degree of control on the front.

TIPS FOR LIGHTING EXTERIORS

As sun and shadows help form the massing effect necessary for a successful exterior shot, you should analyze the subject to determine exactly what different effects can be achieved by maximizing the changing balance of tone created as the sun travels its course. Study the subject with care if you want to capture that expressive play of sun angle and shadow areas that marks the outstanding architectural photograph.

Some buildings seem to cry out for a certain distinctive lighting while others can be captured equally well under a variety of conditions. What the client wants will enter into your decision; if he specifies an emphasis on planes or texture, you'll select a degree of sidelighting. If not, you'll probably choose a flatter, frontal lighting but use care here, as uniform lighting tends to destroy form and the way you light a building can make or break your final photograph.

If your assignments are in the northern latitudes or sections of the United States—stretching from the Canadian border to the south about 500 miles—the sun travels different paths from east to west during the four seasons of the year. On March 21st, the sun rises almost directly east and sets on a direct line to the west. This means that early morning or late afternoon pictures are impossible to take if the building elevation is facing north or south. The height of the sun at midday has increased and the angle of the sun's rising or setting increases on buildings facing north as the month of June nears.

On June 21st, the angle reaches

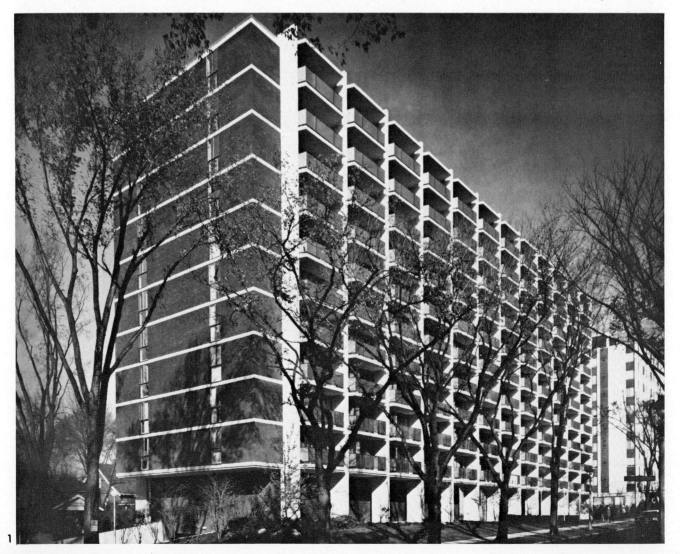

1

23 degrees and will slowly decrease from this date on toward the fall of the year. On September 21st, the sun reaches 0 degrees latitude, swinging slowly to the south. Then on December 21st, it reaches approximately 23 degrees latitude on buildings facing south. However, there is an exception in that the sun rises three hours later and sets three hours sooner than on June 21st and the angle that the sun reaches in the sky is reduced considerably. This is a good season to get clean-cut "night" pictures of buildings or interiors. If the building is well lighted, either by spotlights from the exterior or by the usual interior room lights, or preferably by both, arrange your camera angle so that you are facing toward the sunset.

Take an average light reading from several of the lighted rooms and then at the camera site, take a reading of the sky. When the reading of the sky reaches one-half f/stop below that of the lighted rooms, take the picture. Black-and-white films will require no filter; try a CC20R or 30R filter when shooting with Ektachrome L or Ektachrome Daylight film if the building interior is lighted by fluorescent lights. At times, even a 50R may be desirable.

Building exteriors in the winter months of the year often serve a double purpose. New-fallen snow will cover ugly, dark foregrounds and serve as a reflection to the face of the building. Night photography of buildings is not an exact science and will require experience and patience, and at times, even hardship. One of the authors has taken building exteriors in winter when the temperature was 20 degrees below zero. In such

1. Contrary to first impressions, some obstructions may be definite photographic advantage. These trees add interest and additional drama to already dramatic structure. But what if no trees exist in exactly the right spot? Many photographers collect file of tree and cloud negatives for just such uses. Tree negatives are usually tree branches and leaves taken against clear sky so they can be double-printed with other negatives. Cloud negatives should be taken in spring and fall when most beautiful clouds appear.

2. Building on page 39 was photographed several blocks away later using 12-inch Tele-Xenar lens, which exaggerated perspective but added element of dramatic highlight.

3. Twilight pictures are normally taken an hour or so before sunset. In those cases where the builder has not been cooperative in placing his building appropriately, a sunrise may work equally well. Technique, exposure and results will be approximately the same; only the photographer must adjust—he has to get up early.

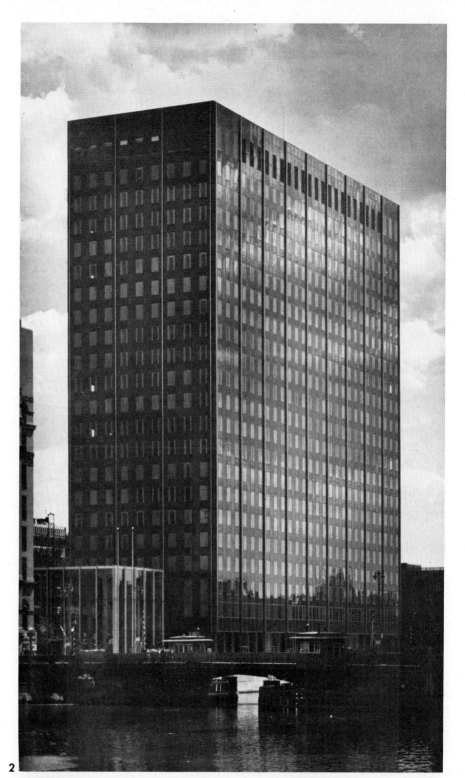

2

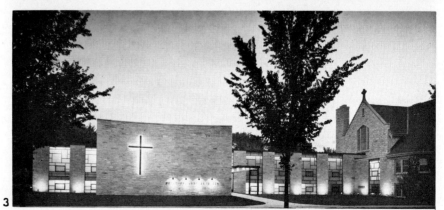

3

Exteriors

extremely cold weather, use the Bulb setting on your shutter as the escapements in most shutters do not operate accurately in such weather unless specially treated. Sometimes, the shutter will open on the one-second setting, but will not close at all until the camera is back in a 40°F temperature. Regardless of their type, even the most reliable shutters will tend to act erratically at 25°F, which is only a few degrees below freezing.

If two elevations are to be taken of a building, the shadow side should be "texture-lighted," not in deep shadow. This requires an angle of the sun of about 10 to 15 degrees horizontally, and about 15 to 25 degrees vertically. The corner of the building should be approximately one-third of the distance across the horizontal area of the negative either left or right of center and if possible, the sky should exceed the foreground area by one-third, unless the foreground is extremely colorful, such as it might be with gardens, reflecting pools, or other landscaping.

In modern architecture, buildings are getting more curved lines and this is particularly notable in roof structures. Parabolic roof structures are not unusual and they make for particularly interesting pictures. Be careful of the angles at which you shoot

them or you may spoil the effect normally created by the unusual shapes.

Sometimes lighting will bring out errors in construction. Architects and city planners have gone in heavily in recent years for pre-cast cement-unit construction or poured-cement over pre-formed molds to gain unusual effects and lower costs. This is an inexpensive way to catch the eye from a distance but tough on the photographer who can't locate a good retoucher or can't afford to pay the price once he finds one. Many times an architect will frown upon destroying the "natural effect" by retouching of the photograph. But board-mold overlays, rust seeping through the cement from wire or reinforcing, screening, bolts, etc. do not add to the pictorial beauty of the design, particularly when the cement is in the final facing of the building. Texture lighting will show up these mistakes (or intentional designs) and in the eyes of many will be distracting from the overall beauty of the building. A partial solution to this problem is to work when the lighting is cloudy or hazy, as this will tone down the contrast of the picture, making the defects less dramatic in appearance.

If you're photographing dark brick facing, you may encounter another and somewhat unexpected problem. To cut some of the high cost of masonry construction these days, con-

tractors use mortar that is mixed very light and thus slow-setting. If the bricks are laid on a sunny day and it rains during the night or the following day, the mortar tends to run and will deface the dark brick. The mortar flows down over 10 to 30 feet of brick, forming white streaks or "flow marks." Unless it's later sandblasted off, the marks will remain in the final building. Infrared film used with a G or F filter is about the only answer to removing these kinds of marks in the photograph. With color film, it's impossible unless a great deal of retouching is done to the print. Should a transparency be desired by the customer, it's better to shoot the picture in a large format with negative color film, then print, retouch and reduce to a color transparency by copying the retouched print.

When photographing brick buildings with infrared film and a G, F or A filter, remember that this film is sensitive to the infrared rays of the sun and reacts in exposure from the percentage of reflectivity from certain colors which will be found in mixtures of brick. Solid red colors, light or dark, will prove the best facing for uniform tonal masses. But during the last few years, architects have used mixtures of brick colors; it's not uncommon to find colors ranging from almost charcoal black to deep, dark blues intermixed with red, deep orange or yellow. Since infrared film

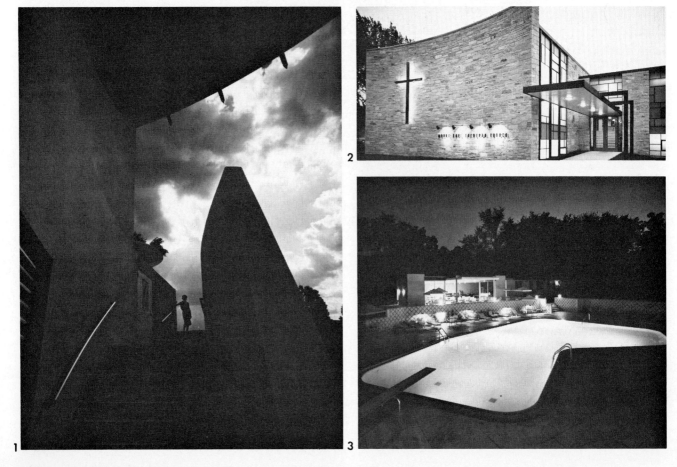

4

1. Not only does this low-key shot show drama of one of the staircases leading to a garden, but it also shows relative size of structure. Average woman is about 5'7", while average man stands 5'10". If fairly accurate size comparison is important, choose models carefully to avoid giving distorted impression.

2. Most buildings have some central area of interest, and detail shots are often important to client. If such an area is not evident, try twilight exposure with building lighted in some part that has potential interest. Here, the sign tends to catch the eye first.

3. Dramatic after-dark scenes of well-lit areas can be made as easily as daylight scenes, particularly if it is not totally dark when they are made. This twilight shot was printed high contrast to make scene appear darker than it actually was.

4. Outdoor/indoor pictures add an extra illusion of depth to rooms with large window areas. Most such shots can be successfully accomplished by time exposures. If building is lit outside by floods on or near structure, exposure may be possible without additional lights (or by substituting photofloods for regular bulbs). Some photographers expose for interior, then fire one or more flash bulbs outside. Greatest problem with this technique is unanticipated reflection in windows, but it can be avoided by having assistant hold flashlight at position where flash is to be fired while photographer checks his ground glass for reflections.

5. In many pictures of buildings, type of construction materials used is of primary interest. Here the architect wanted to highlight multi-color bricks of wall, but they tended to fade into overall gray in regular exposure. Use of A filter and Pan-X film produced desired contrast.

6. There are times when some details of construction may be undesirable. Weather had caused mortar to badly stain stone on these columns, but defects were rendered invisible by using infrared film with G filter.

5

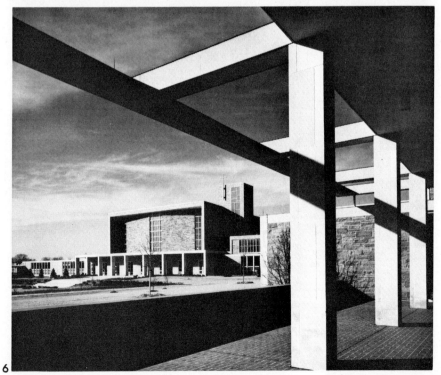

6

Exteriors

is not sensitive to charcoal black, blues, or blue-greens, a photograph made of bricks with these colors mixed with orange, red or yellow brick will produce a result not unlike a polka dot dress. About the only solution to this problem is to use a panchromatic film and experiment with various filters to get a pleasing result.

FOREGROUND CONTROL

Before moving on to specific exterior work, a few words are in order concerning foregrounds. We assume that the reader has a basic understanding of the fundamentals of composition (if not, acquire a copy of Petersen's Mini-Manual entitled PhotoGraphic Guide to Composition) and so will not dwell on the topic other than to offer some specifics pertinent to foreground in architectural photos.

A foreground should not be too large nor should it be too empty; one that adds balance to the composition is to be sought. With the popular elongated ranch-style architecture used in modern homes, schools, commercial plants, etc. in many areas of the country, cropping of the final print is essential, especially if the foreground consists of grass or pavement and the sky is blank. It's helpful if you can avoid an uninteresting foreground by picking a camera position that includes shrubs, trees or overhanging branches to use as a frame..

If this is not possible, consider the use of infrared film where the foreground is asphalt pavement. If the foreground is grass, forget the infrared film as the extreme absorption of infrared rays will burn out the negative. In this case, a panchromatic film used with a K2, G or X filter is a far better choice. In order of importance then, you should try to control foregrounds by camera placement, camera corrections, compositional arrangement, film and filter choice, or cropping in the darkroom. Now let's examine a specific case history.

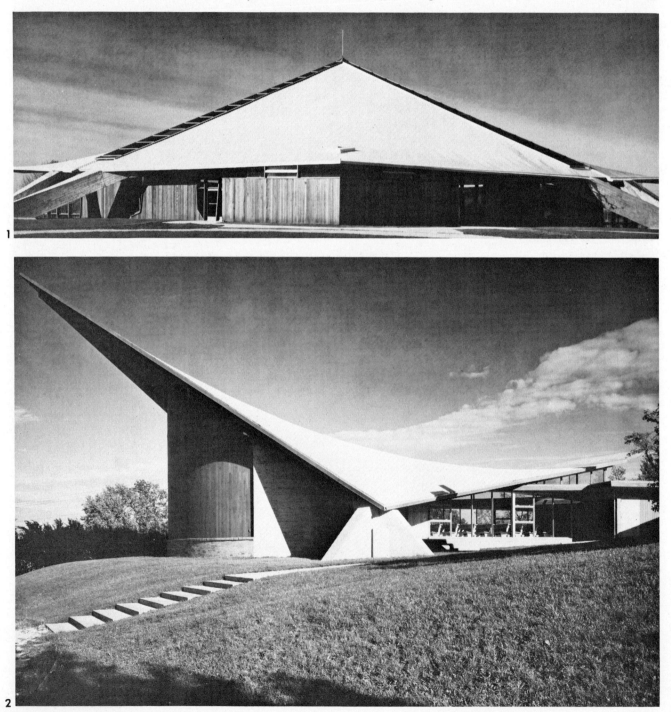

1

2

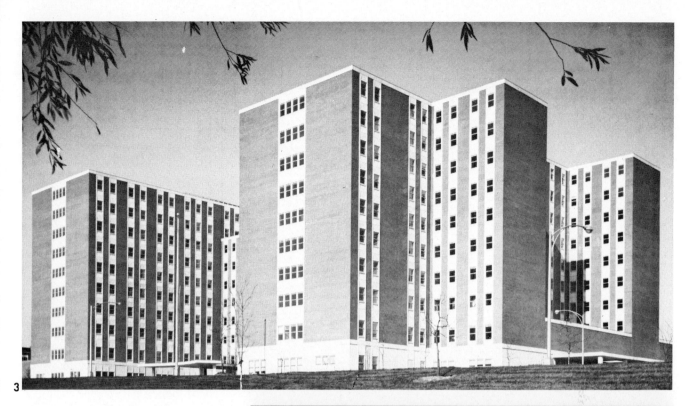

3

4

5

1. Long, narrow picture is frequently the answer to low, long building. Additional foreground or sky would take away from stark aspects of the building.

2. By taking picture at this position, photographer achieved dramatic angle, yet is still almost level with building. Apparent slope of foreground tends to further "soaring" of roof line. Note shadow of tree over camera, which tends to further increase feeling of depth.

3. Sometimes you can create best picture by not showing all you can. This newly completed building was still not cleaned up at ground level, so photographer moved down a sodded slope. Few people notice that first full floor is not shown. Tree leaves give additional feeling of depth.

4. Bank presented photographer with more problems than can be seen immediately in finished picture. The building is long and rather low, which means normal 8x10 print would result in excess of sky and foreground. This was overcome by cropping, but matter was further complicated by tiny sign on top. Photographer solved problem by darkening sky, first by using infrared film and then by further work in darkroom.

5. What's wrong with this picture? Photographer chose to include plant in foreground for depth; however, unfortunately shadow of telephone pole was also included. To make standard 8x10 print and get entire building in picture, it's necessary to include bush, telephone pole and all. You should develop an eye for such problems, which usually show up just as prominently on ground glass. Selection of higher angle would have avoided problem, but only alternative now is to crop negative to make narrow print or cut off part of building.

Interpreting Architectural Moods

Regardless of the building or style of architecture involved, there are many moods to be captured and the professional architectural photographer does not simply set up his camera and click off two shots (one for insurance), then pick up and go home. On the following pages, we give you a photo series as a sample of what can be done to a simple structure known as the Planetarium located in Milwaukee. These three domes, which required five years to construct, house every flower known to man and the assignment to photographically interpret the unique structures was given to Big Cedar Studios in Brown Deer, Wisconsin to handle.

The initial camera setup was a straightforward, nearly head-on shot which included two of the domes. Lighting them from the side provides dimensional quality to the structures

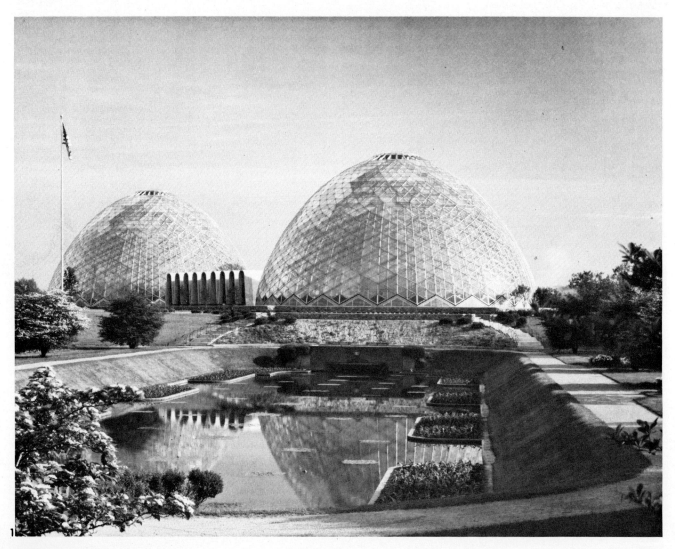

while panchromatic film was used with a K2 filter to introduce separation between the domes and the somewhat bleak sky background. Their upward thrust and the inherent feeling of depth in the sunken garden/pool foreground visually offset the centered horizon line.

A second shot was made from the same camera position but infared film and a G filter created a shift in tonal

1. Buildings that are photogenic in themselves should be photographed in settings that add to their interest. Straightforward shot in this case may prove to be best approach.

2. Here the setting has not changed but the shift in tonal value caused by use of infrared film is as dramatic as two different seasons of year (or day and night, if you wish to create a moonlight effect).

3. A change of lens, use of pan film and a filter and the resulting frame of foliage produce an entirely different mood.

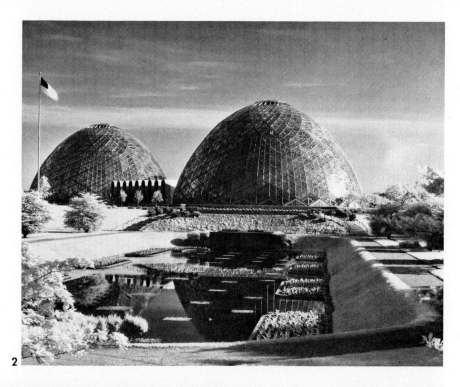

2

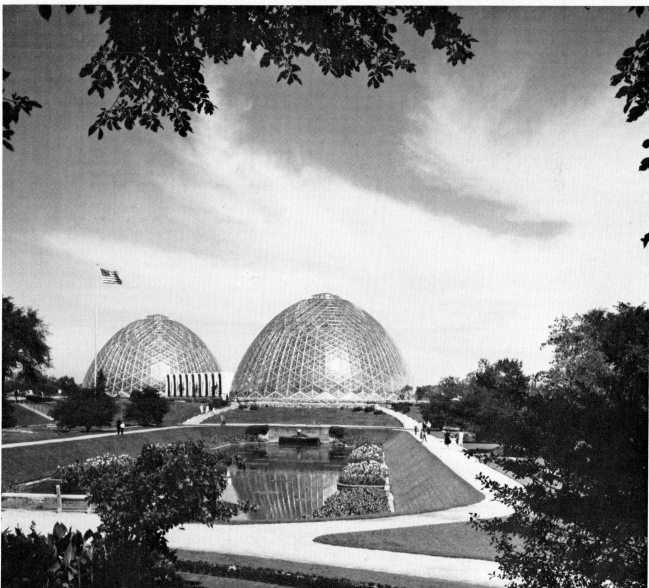

3

Architectural Moods

values that places an entirely different visual perspective on the photographic approach, adding impact and giving a rendition that has the feeling of a moonlight exposure.

A change in lenses without changing the camera position and a return to a pan emulsion with the G filter results in another dimension of the domes. This time, the tree branches across the top and right side of the picture provide a frame that helps to fill in the sky. The horizon line was dropped somewhat to accommodate the frame effect.

Another camera position was chosen to portray all three domes. Infrared film with an A filter darkens the sky and brings out the cloud background in contrast to the darkened domes. We'll leave it up to you to determine if the branches forming this frame are real or a darkroom addition to the print.

Moving in closer for another approach, pan film was used, first with an A filter and then with a K2. In the former picture, the direction of lighting was on the domes while in the latter, it was a semi-backlighted interpretation in which the light passing through the structures reveals the construction more clearly.

Late evening offers a completely different view of the Planetarium that not even infrared could capture and returning to an earlier camera position for a night exposure, the photographer reveals the subject in still another mood. Treating a subject this thoroughly can give you an impressive portfolio as well as pleasing the client beyond his wildest dreams.

The wise use of a combination of camera position and correction, compositional arrangement and film/filter choice allows you to explore and interpret the many moods of a single subject. And that's one of the reasons we maintain that architectural photography is as exciting and challenging a venture as you could hope to undertake.

1. Effect is less seasonal from another angle, but it still has impact when infrared film and an A filter are used for shot.

2. Panchromatic film and red filter (top) or yellow filter (bottom) create pleasing but not as compelling pictures, yet by altering direction of lighting on the subject, entirely different moods are produced.

3. Darkness brings effect that even infrared film cannot match, and buildings such as these seem to call for late evening (top) or night (bottom) exposures. Amateur photographers seldom realize the variety of moods inherent in a single subject.

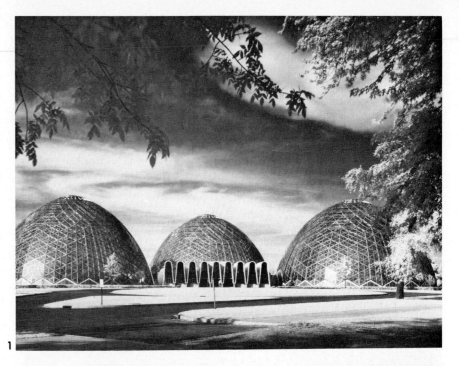

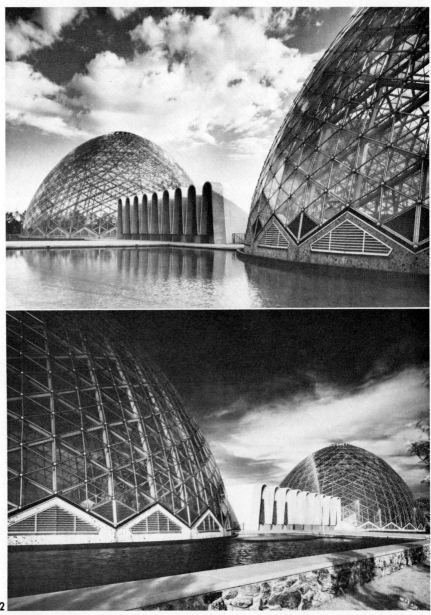

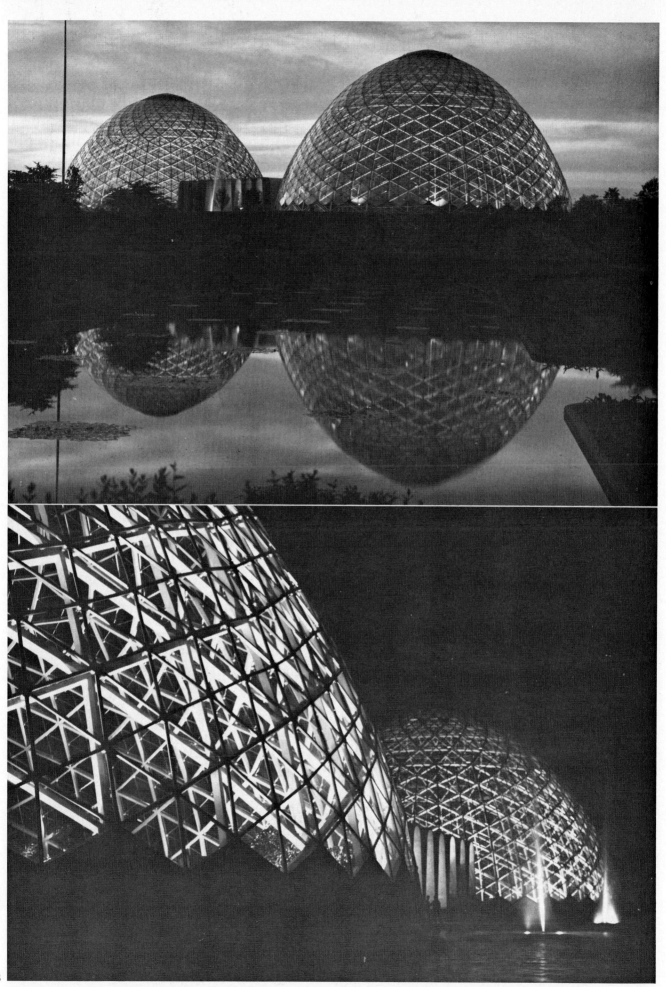

Working with Interiors

Architectural interiors present the photographer with an entirely different and considerably more complex set of problems; while you may eventually be able to reduce exterior work to a somewhat standardized series of formulas (depending upon the type of assignments you accept), you'll find that each interior is a completely new problem in itself—primarily because of two factors: lighting and the more limited working space available. Every room of a building—large or small, old or new—becomes a challenge. All interiors are different—they have different shapes, different furnishings, different color schemes—and each will require a different approach.

Hopefully, we've not scared you from reading beyond this point, as once the intricacies of interior work are understood, along with the methods and means for coping with the challenges it presents, you'll find that while interior photography is far more demanding (and rewarding) than exteriors, the variety encountered is truly the spice of the architectural photographer's life.

Ask any top professional his secret of success and the answer will invariably come back, "Keep the lighting simple." Yet the inevitable human response to complex problems tends to be complex solutions and nowhere is this more universal than in interior photography. But let's look at some of the types of problems you're likely to run across and see if we can reduce their complexity to simplicity in the process.

LIGHTING

It's true that light and lighting play a more important role in interior work than they do when shooting exteriors, mainly because you have so much control on one hand and so little control on the other over exactly how the scene can and will be lighted. As correct lighting is necessary for correct exposure, you should realize that light streaming through a window is not necessarily desirable as it often creates very strong contrasts—brilliant highlights vs. deep shadows. This should give you an insight into the nature of some of the problems posed by interiors, especially when working with available light in churches and other buildings where the height of the structure exceeds the degree of penetration provided by the small amount of light that enters through the windows.

As lighting is about the only possible way of creating depth, relief and atmosphere—the three factors most responsible for successful interiors—you can imagine the frustrations involved in photographing an interior where it's desirable to emphasize texture if the illumination is distributed so uniformly that no shadows are cast. One of the essential ingredients then in working with interiors is the development of a feel for correct lighting effects and the ability to recognize when you've obtained them. Sounds very elemental, but you'd be amazed at the high percentage of incompetent interior photographs that circulate among advertising agencies, public relations firms and real estate offices.

Considering the lack of maneuverability in camera placement, it's very important that you gain control of the light to prevent harsh contrasts with clogged highlights or black shadows without detail. When working with available light inside many buildings, especially those of older design where window size and placement tend to reduce the amount of light, you'll find that the best lighting to work with is diffused. Providing that your exposure is sufficiently generous, diffused light entering through windows will provide enough brightness to supply the required contrast while allowing adequate shadow penetration for registration of essential detail. With the more modern designs, you'll find that the general scheme of interior lighting is more evenly distributed and that while the sunlight outside may be very bright, no really harsh shadows will be cast inside.

The geographic direction in which windows face determines to a large extent just what the lighting effect will be when you're working with available light. If there are windows on more than one side and the exterior illumination is brilliant sunshine, light entering the room will "overlap" and increase the brightness range in your picture, complicating matters considerably. In such a case, you're best off if you can shoot on an overcast day. Problems are minimized when the interior to be photographed is lighted by windows on the north side. Direct sunlight will not prove a headache in this case and for all practical purposes, the lighting will remain essentially the same throughout the day. In winter climates, the effect of light reflecting inside from a fresh snowfall outdoors should not be overlooked; in many cases nature provides an effect that we would be hard pressed to duplicate and the enterprising photographer gratefully welcomes all the help he can get.

Although hard and fast rules are difficult to formulate without a lengthy list of exceptions, there is one you might keep in mind as it affects composition—try to keep the highlight areas in a reasonably central position so that shadows will gradually deepen near the edge of the picture. While this may not always be entirely possible, the reverse should be avoided if at all possible—highlights should not

1. Not every building has spectacular view such as that provided by this spiral staircase. Wide-angle lens helped to record more of stair and give added depth. Dramatic natural lighting was heightened by waiting until sun cast strong shadows.

2. Great depth and overall balanced lighting are two objectives of every architectural photographer. Lights reflecting in plate glass at rear are scarcely noticeable in this highly successful example.

Working with Interiors

reach to the edge, as they'll carry the eye right with them out of the picture prematurely. Try to achieve an effect wherein the light tapers off gradually instead of having highlight areas bordered by deep shadows.

SUPPLEMENTARY LIGHT

As available lighting is often too unevenly distributed or produces an illumination level that's too low for an acceptable exposure duration, the photographer may find it necessary to supplement the existing light with some of his own. This is especially true when working with color film, as the quality of light available may be unacceptable for proper color balance. But there are tricks that can be of help in photographing interiors—one is the time-honored technique of "spraying" or "painting with light."

To get the most from low levels of available light, you can sometimes use one or more 500-watt photospot bulbs on a light bar which is kept in constant motion during exposure. For best results, light should be "sprayed" on one side of the room during half the exposure time and on the other during the second half. Secure the camera on its tripod and set the shutter for a time exposure. Take a meter reading for available light, then one for the supplementary light and average the two. It's not uncommon to expose for a full minute or more at the desired f/stop.

Opening the camera shutter, move quickly to one side of the camera and rotate the light in a circular motion to fill dark areas, ceilings, etc. for half of the exposure time. Do the same on the opposite side for the remaining half of the exposure, taking care to keep the light from striking the foreground or any other object that's near to the camera. If the interior is to appear to have been lighted by the existing room illumination, turn the lights on for a very brief exposure after you've finished the basic spray exposure. To use the room illumination while you're exposing the entire interior would mean an overexposure of the lights and the areas around them, causing a loss of detail and introducing a very artificial effect that destroys the entire illusion.

If the subject happens to be a church interior with many stained glass windows, try to arrange your shooting session on a cloudy or rainy day so that the detail and color of the stained glass will not "burn-out" while the interior is being exposed with the "spray" technique. Unfortunately, the technique is useless if you're working with a marble interior, or if there are tile-faces such as al-

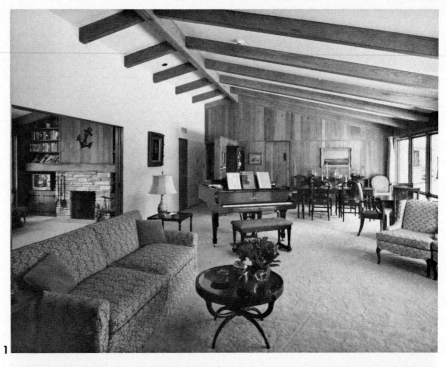

4

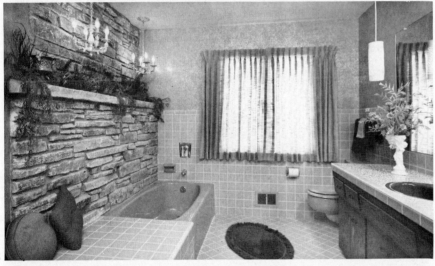

5

6

tars, floors, columns, etc. as the highlights become like mirrors and "burn-out" on the film. For situations like these, bouncing your light is more suitable, as we'll see.

Whether working with a home, church or commercial interior, striking lighting effects are vital in many modern buildings to gain a really dramatic picture of what usually proves to be an otherwise dull and drab interior. Narrow and wide-beam spotlights are a necessity in such cases, with as many as four or six required to do the job. As you gain practice in the field of interior photography, you'll come to realize that lights are to a room as a brush is to the artist's hand.

Suitable effects can also be achieved by the use of multiple lighting and a single exposure. If flash bulbs or electronic flash are to be used, check their placement by substituting photoflood or ordinary household bulbs at the position where each flash is to be fired. If this proves impossible for any reason, use a Polaroid Land back and determine the correct light placement by making a series of Polaroid exposures as you position each flash. While arranging the room lighting with your floods,

1. Existing light is not always best for showing off a room to its best advantage, but in this case it's both appropriate and adequate thanks to a wall of glass.

2. Depth can be more than focus alone, as shown in this two-room picture. Contrast of lighting highlights both areas and gives extreme depth an even greater impression.

3. Available light coupled with undesirable outdoor scene does not work well in this setting. While client might desire shot like this for record or other purposes, you should avoid almost impossible balance in exposure required here.

4. Where was photographer when this picture was taken? Standing on ladder at first landing. This provided better angle of entire bannister, gives viewer feeling that he can see entire stairs.

5. Luxurious bathroom can prove to be photographer's nightmare. Widest-angle lens available is usually required, and reflections in mirrors are a problem. But there are some compensations as relatively small and bright rooms can make bounce lighting ideal answer.

6. Stage lighting is always problem, and this auditorium photographed primarily by existing lighting is an example. One flash was used at camera to highlight backs of seats and keep them from becoming one solid black foreground. When acceptable to client, such lighting can be more interesting than that of fully lighted room. Flooding this scene with light would destroy entire mood.

Working with Interiors

lamps and other fixtures should be turned off to prevent their interference with the overall effect sought.

Bouncing light may also prove expedient under some circumstances, especially where relying entirely on direct lighting may lead to burning-out of highlights. The soft, hazy quality of bounce light gives a broad, even fill-in effect that eliminates the double set of shadows often cast by furniture legs. As bounce light tends to produce shadowless results in comparison with other lighting techniques, you may want to accent the resulting flat lighting by directing small spots into the scene. Bounce your light with care, especially if there's a good deal of furniture in the room, as strong top lighting will alter the relative brightness between the top and side of furniture in the final picture.

Such interrupted or "series" exposures cannot be used in situations where non-stationary objects are included or where existing light levels are high, as from windows during daylight hours. Using the open-shutter method will result in overexposure of such areas; a better method is to use high shutter speeds with synchronized electronic flash—and here's the answer to our earlier question concerning the advisability of acquiring a flash-synched shutter.

The majority of the illumination from the flash is used, just as it is with a time exposure, but the total exposure time for the available light is reduced to the product of the shutter speed and the number of times the shutter is opened—10 exposures at 1/250 second are approximately the same as one at 1/25 second. We say approximately because of possible differences in shutter accuracy at the two different settings as well as the intermittent effect.

This technique is helpful in obtaining a good balance in scenes where the exterior is included, as in a room where one wall to be shown in the picture is all-glass. You can control the exposure to daylight with little or no effect on the flash simply by variations in exposure. The camera and tripod should be sufficiently rigid to allow repeated recocking of the shutter without danger of moving the camera. If possible, attach a second cable release to the lens board to re-cock the shutter without touching the camera.

In circumstances where you are faced with an overly bright or flare area, such as a ceiling that's far lighter than the floor and walls, you can bring the inequality of brightness under control with a rather exotic

1

2

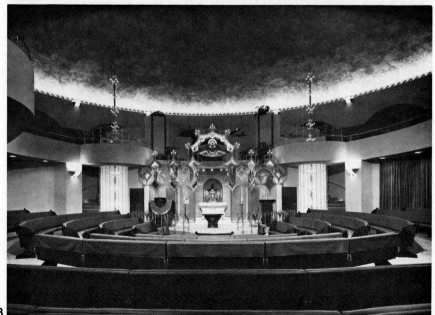

3

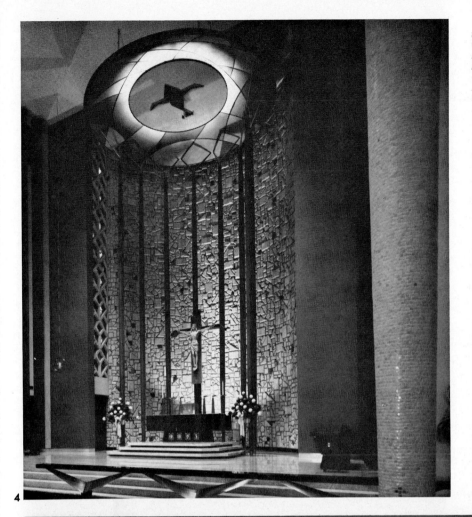

1. Different problem was faced with these windows. While outside light was adequate for windows, inside lighting had to be strong enough to balance exposure or leading of the windows would have been burned out. Fairly weak sunlight was used with fill light at camera and photofloods in wall fixtures to give appearance of normal lighting.

2. Stained glass windows photographed with bright sunlight streaming through can pose an exposure problem. Here it was necessary to include both windows or a camera placement more nearly parallel to large windows would have been used.

3. This unusual church interior was photographed with traditional center balance but little would have been gained by taking it at an angle. However, it is often best to avoid symmetry such as this if possible.

4. Many churches are purposely designed to provide dramatic effects, and at times a simple time exposure will provide excellent picture. In this case, additional fill lights in back add to overall modeling of altar by reflecting off metal rail.

5. Interest should be added to break up otherwise gun-barrel effect when photographing long interiors with flat, unlit ceilings. Here heavy spotlights were used and aimed about ⅓ the distance from the back. While not perfect, the desired effect of spotlights was to make light appear to be coming from stained glass windows at sides of room.

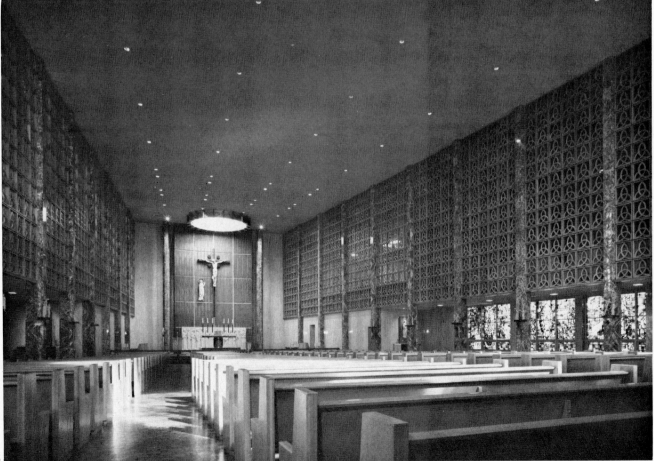

Working with Interiors

technique called "camera dodging." To work this one easily, you'll need an adjustable bellows-type lens shade like the Calumet or a matte box, and some black cards. Check the ground glass image and position a card in place—varying that part of the total exposure during which the card is used will determine the degree of camera dodging. If you use the bellows shade, the dodged and undodged areas can be blended by changing the distance between the lens and the card.

As the black card must be removed with a minimum possibility of camera movement, here again you'll need a rigid tripod/camera setup. Although this is a tricky technique that requires practice to achieve predictable results, it has two distinct advantages over relying upon the film's characteristic curve and latitude to record detail sufficient to permit corrective dodging in the darkroom. Flare areas are not as likely to degrade other parts of the image, and most important where production printing is involved, it's not necessary to dodge each print that's made.

CHOOSING CAMERA POSITIONS

While the selection of a camera position will depend upon the room under consideration, your freedom of choice is severely limited, when compared to the 360-degree approach possible in working with exteriors. As a general rule, overall views should be photographed with regard to their balance but you'll often find it more advantageous to work from a slightly oblique angle to avoid symmetry (as well as unsightly reflections) in subjects such as church interiors, where a direct frontal camera position results in equal distribution of the subject on both sides.

Although it's impossible to state fixed rules regarding camera placement, don't overlook the height at which the camera is placed. While the viewpoint chosen will depend upon what you wish to show in the finished print, you should at least consider the differing effects obtainable from working with the camera above or below eye level.

When photographing the interiors of churches, older schools and many public buildings, you'll find the rising front to be very helpful in including high ceilings that lend atmosphere to the picture. In such cases, the ceiling usually holds more than just passing importance for the finished print. One all-too-common mistake in this situation is camera placement that results in a sharply rising floor with a ceiling that gently slopes toward it at the

back. By lowering the camera and bringing the rising front into play, you can reverse this effect and visually create a feeling of distance and height that is otherwise lost when the floor appears to rise too sharply.

Which brings us to the question of foregrounds in interiors. Here control is also limited, but for a different reason. A sufficient amount of foreground area must be included to create the visual impression that you're actually looking into the interior of a house, church or schoolroom. In certain cases, it will even be necessary to include a larger foreground than you'd like to—if columns are used to support roof arches as in a cathedral, there must be sufficient foreground area included to visually support the

columns. Such features require enough foreground in which to stand or they tend to appear visually awkward and out of balance.

FOCUSING

Focusing for a sharp image can prove to be somewhat of a problem when photographing certain interiors by natural or available illumination. If it's possible to position someone with a flashlight in various areas of the composition, the problem can be alleviated to a large degree, but here's where using the focusing magnifier to check the ground glass image proves invaluable. When no assistance is available, the best method is to focus precisely on the brightest area, which usually occupies the center of the picture area, and then stop down the

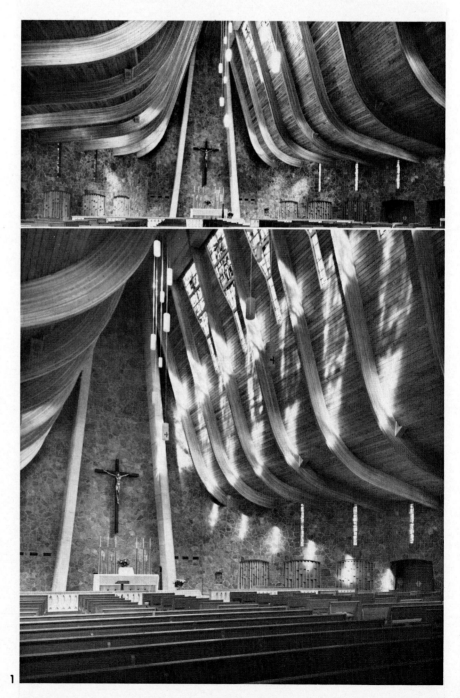

1

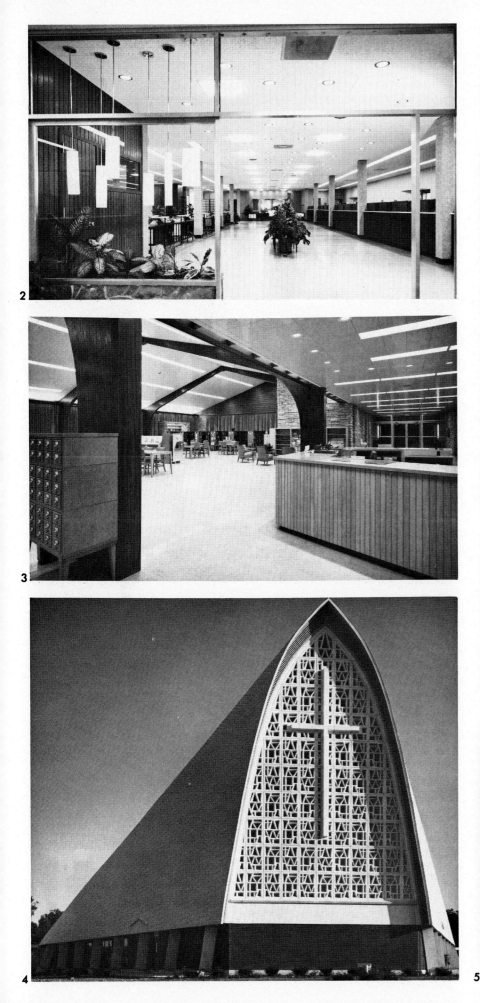

lens to provide overall sharpness.

Every photographer is well aware that stopping down a lens increases depth of field, but not all realize that each lens has an optimum point beyond which overall definition begins to break down, even though

1. By tradition, church interiors are taken with altar in center of picture, but overall effect here is less in angled shot with altar to left and laminated beams of ceiling giving full soaring feeling of the architecture. Natural shadows of stained glass constantly draw eye to upper center of angled photo and may be either distracting or thing that makes picture, depending on your point of view. Printing-in foreground seats creates frame for rest of shot.

2. Long passages are no problem to expose properly if they're as well-lit naturally as this one. But the necessary depth requires such small f/stops and long exposures that it makes inclusion of living models in such pictures impractical.

3. Whether interiors or exteriors, pictures taken through an arch create natural center of interest. In this case, depth and apparent size of room are expanded by angle used.

4. By way of contrasting greater problems involved in interior work, this window presented no particular problem in exterior as long as right time of day was chosen. Shadows cast by low sun help window to stand out. Darkening sky in printing also helps in strong contrast of window.

5. Church interiors present definite challenges; with tall structure such as this, it may be necessary to use camera adjustment to correct perspective. But exposure is real challenge here as exposing for interior by existing light will overexpose window and exposing for window alone will turn interior too dark. Strong bank of fill lights was used to left while photofloods replaced some regular lights on either side of arches. Left fill lights were kept low to highlight altar. Same general effect can be achieved by careful use of medium-power flashbulb.

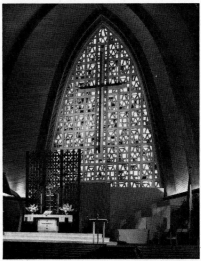

depth of field continues to increase. This is not as great a problem with lenses of modern design, as their manufacturers have provided protection in the form of limiting the f/stop range, but with older lenses that you may acquire second-hand, this can be a very real limiting characteristic.

Regardless of the lens you buy—new or used—it's a good idea to test each to determine the smallest practical lens opening at which critical definition is consistent with depth of field. Even with new lenses, there can be variations in manufacture that may occasionally lead to surprises, despite the sophisticated technology involved in present quality-control programs.

EXPOSURE

There are few guides for correct exposure more reliable than an accurate light meter that has good sensitivity to low illumination levels. While photographers have long argued the merits of the reflected vs. incident method of exposure determination (and will continue to do so), we hold the position that both have their place in interior work and as the photographer, you should develop the ability to discriminate between interior lighting arrangements, selecting the method most appropriate to the interior with which you're working. To further this position, it might be pointed out that a reflected-light reading taken from the camera can be highly misleading if the brightness range of the room differs greatly from front to back, or even side to side—know when and how to use each method correctly.

One cardinal rule often quoted in photographic literature is the age-old axiom—expose for the shadows. If the shadows are really deep, following this advice can lead to overexposure of highlight areas that will in turn burn-out their detail, thus the necessity of knowing and understanding the characteristic curve of the emulsion you're using. If you can register the highlights along the shoulder of the curve, you'll be all right. But there's also a trick or two that can be used in negative development that will help in obtaining a good rendition of both highlights and deep shadows. We'll cover these in a later chapter.

Even though you're equipped with a good, accurate meter and can differentiate between the appropriateness of the reflected/incident controversy, bracket your exposures one-half f/stop over and under. The cost of film is inexpensive when compared to reshooting a job because you neglected to take some small point into consideration. Although some feel that the photographer who brackets

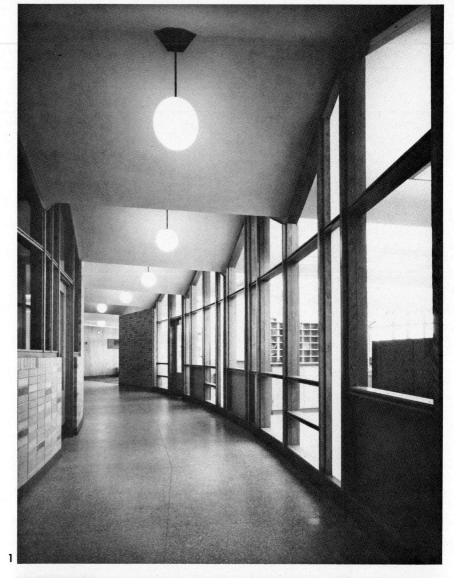

1

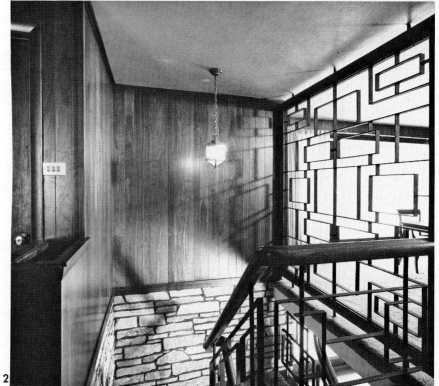

2

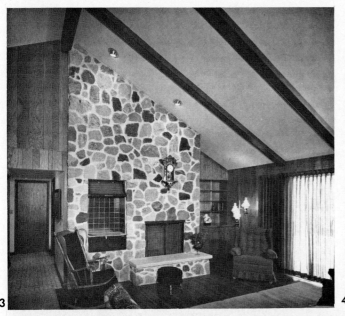

3

4

5

1. If a building has patterns and natural curves or angles, they can provide both interest and feeling of depth. Here it was possible to photograph hall with existing light, but fill was used at end of hall to avoid making it seem endless.

2. Home interiors almost always require wide-angle lens, unless relatively small area is desired or rooms are exceptionally long. Existing light provides good deal of lighting here, although not as much as it first appears. Flood has been used to fill in shadows on lower level, while other fill lights were used at both left and right of camera.

3. House that's unoccupied usually will look better with at least a few basic pieces of furniture. In this room, only very limited amount of furniture was available and almost no accessories, yet to casual viewer room appears to be fully furnished.

4. Here's different approach to photographing long, narrow room. One wall reflects while curtains, although behind glass, tend to absorb light. Bank of floods to left of camera aimed at diagonal across hall caused minimum reflection and adequate illumination when combined with regular room lights. Note one small flaw—part of flood light can be seen in the rear mirrors.

5. Interior court of this office building appears to have been photographed with available lighting. Actually, side rooms were each augmented with reflector floods (note strong shadows in first room on right). In addition, floods were used in area below camera—note telltale reflections on walk.

his exposures isn't confident of his ability to "bring it back alive," we think of the technique as protection or insurance, and thus a practice that all should use—suppose that single negative is scratched or developed incorrectly?

CHECK BEFORE SHOOTING

Photographing interiors also differs from working outdoors in that there are often innumerable small obstacles to be taken into account, many of which are peculiar to the particular interior. In bringing our consideration of the subject to a close, here are 10 of the most common with which you'll have to deal:

1. Camera placement and adjustment affect the relationship of vertical lines—are they all parallel?

2. The atmosphere, mood or feeling to be conveyed in the print can be altered by lens choice—would a longer or shorter focal length than the one on the camera reinforce the desired effect?

3. What the camera sees, the camera shows—an altar cloth incorrectly positioned will destroy the illusion of reality—is everything arranged in its proper place?

4. Pictures likely to be published at a later date may require a seasonal touch—should you add such items?

5. The camera will look through

Working with Interiors

windows and so should you—does the view detract from the interior, and if so, what can be done about it?

6. Accenting may be helpful when interior lighting is flat—try a flash or photoflood bulb in shaded room fixtures for natural results.

7. Reflections or excessive glare can ruin your picture—use a bit of salad oil on metal or dulling spray on wood to control shiny surfaces without destroying the overall gloss.

8. Closed doors intrigue some and annoy others—if they are to be included in the picture, shoot one exposure with them open just in case.

9. When included in an interior, people can easily become the center of interest—are they suitably dressed and positioned to be subordinate to the overall composition?

10. Interiors that blend two or more types of lighting can cause balance problems when shooting color—is the filtration you've selected correct for the mixture of light?

Develop the habit of tidying up such loose ends before tripping the shutter and you'll prevent a good deal of frustration and disappointment later, as well as avoiding reshooting sessions that will do nothing for your reputation or your pocketbook. 🜨

1

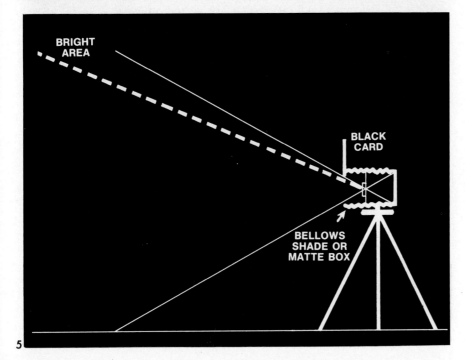

1. Narrow cluttered areas present special lighting problems. In this picture, photographer used many of existing fixtures for primary lighting by equipping them with photofloods, while fill lights were added behind each boiler on left side and at rear. Another bank of lights was aimed partially at ceiling from the camera position.

2. By replacing normal bulbs with photofloods and adding fill to left near camera and second fill behind partition, this natural effect was achieved. Intent here is to show slate floor and natural woods of walls and ceiling.

3. Interiors that blend with light coming from exterior are possible in modern buildings with high fluorescent light levels, but this can cause difficulties with color films. Here plants not only add depth, but also cover strong light from doors that would otherwise cause balance problems.

4. When photographs of kitchens are requested, unstated rule is that the room appear spotless. This is usually minor problem in new kitchens, but major obstacle in older ones. In either case, the more "shine" photo shows, the better. This can usually be accomplished by aiming a few spotlights at glossy surfaces. Use of a little salad oil will bring reflections or excess glare under control without destroying overall shine. Such precautions by photographer can save client money, as he might otherwise have to have areas airbrushed if use in catalog or magazine were contemplated.

5. Black card attached to bellows shade or matte box is used during part of exposure to dodge in camera and control overly bright or flare areas of the subject.

Applying Your Talents

To this point, we've considered architectural photography in the rather general terms of equipment and exteriors vs. interiors. Now it's time to direct your attention to specific applications of your talents and some of the special interest areas you'll encounter. As you establish yourself in the field, you'll be called upon to photograph a variety of differing assignments, such as historic buildings. Here you can apply all the tricks of the trade, as historical structures in American architecture are unusually rich in angles, shapes and texture when compared to modern buildings. As they lend themselves well to a large variety of lighting effects, it's well to fatten your files with as many different treatments as possible for several reasons. Textbook publishers, historical societies, local newspapers and the like are constantly on the lookout for new pictures of old buildings.

Photography provides immeasurable help when restoration or renovation of historic buildings is undertaken, providing a visual guide as to how they actually looked "back when." Semi-historical photos (i.e., those of the community's older buildings that are not necessarily monuments by themselves) may appear to have little value today, but as the buildings are demolished in years to come to make room for newer structures, the resulting pictures will acquire added value. When photographing such buildings, try to avoid dating the picture by including people and modern vehicles, as they often destroy the overall effect of the past.

Photograph historic buildings from all conceivable angles and give them the full treatment of lighting and filtration to bring out the various possible combinations that reveal shape, form and texture. If you can approach them with a feeling of reverence, you'll find that your treatment will exhibit more meaning than simply by considering them as just another assignment to be completed. Unless you genuinely love the architecture of the past, you may find it difficult to acquire this mental "set," but that's part of the secret when working with history.

Construction progress and old vs. new or before/after photographs are other types of assignments that differ from the usual workload of the architectural photographer. Here you have to be absolutely clear in your understanding of what the client desires, as once the old is remodeled, or construction has been completed, it's too late to reshoot the initiall pictures. Before/after photos are usually fairly easy to do as the client is primarily interested in the contrast provided by a set of similar pictures taken with the same camera position and lighting that will allow comparison of the remodeling job. In many cases, *anything* that the contractor might do is going to make that second set of photos look sufficiently different for this purpose.

Old vs. new photographs quite often demand that a sense of continuity between the two be shown. This may be as simple as a physical link between the two, or it may require the choice of a camera position that simulates such a connection. But it's just as possible that the client may want to deemphasize such a relationship and in this case, you'll have to approach the problem from a completely different viewpoint to achieve the results desired, especially if physical continuity is actually present in the form of added-on or adjoining buildings.

While it's always a wise idea to clarify exactly what the client has in mind before undertaking any assignment, regardless of its nature, it's imperative with the old vs. new approach. Just to be on the safe side, it's also a good idea to photograph the subject from both viewpoints despite the client's immediate decision, as later plans may call for removal or renovation of the old structure, which can then bring forth a call from him for otherwise non-existent photos.

Still another of the specialized areas in architectural photography, construction progress work is probably one of the least understood. Here you should seek definite clarification of intent as well as the type and amount of progress to be shown. One of the authors was reassigned from combat duty to an Engineer Aviation Battalion after the Korean truce was signed and his task there was simply to record the progress in construction of a one-mile bypass of the Main Supply Road near Kimpo Airbase. The battalion commander specified that 48 pictures were to be taken daily to accompany the daily progress report sent to headquarters.

Now, no matter how creative you are, taking 48 pictures of the evolution of a one-mile dirt road every day is bound to tax one's ingenuity. And so it came to pass that as a result of this exhaustive coverage being forwarded daily to group headquarters, an inspection team soon appeared to determine why work was proceeding so slowly—not realizing that the insignificant amount of change shown in each day's shooting was the result of too extensive photo coverage and not because the construction battalion was incompetent.

All of which points up the fact that you can overkill (or underkill) by

1. Historical structures usually are rich in angles, shapes and textures. Strong side or backlighting will highlight these features.

2. Semi-historical pictures taken for your files can provide a source of income in years ahead. As buildings are demolished, such negatives become valuable to newspapers, historical societies and even collectors. Collections of historical pictures can often be sold to banks and other businesses to celebrate anniversaries.

3. Pictures from the past are often helped by life, but be careful. While children might fit well into period of schoolhouse, modern bicycles in background spoil overall effect.

sheer volume (or lack of it) and as change if any is likely to be small on a daily basis, it's perhaps a better idea to sit down with the contractor and client for a few minutes and resolve a series of major milestone events that represent a progress achievement that's significant enough to warrant photo coverage.

There's still another aspect to this particular type of photography; whenever any major building is constructed, it's no small undertaking to make certain that everything that's specified on the job really gets done, and at the time it is supposed to. That's where the progress photographer comes in. His job is to take a picture at the exact same spot and same time for a specified number of days, and on occasion, weeks and months. Each picture is a legal instrument and as such, the photographer must include an identifying time, date, location, etc. in the picture. This can be done with specially built cameras, some of which use aerial camera data systems, or a regular camera used with a large clock and blackboard for writing identification data located in the scene. This is rather precision photography as each scene must be precisely the same as the one taken the day before. Should a dispute arise between contractor and subcontractor, or contractor and client, the picture then becomes legal evidence in court. At this point, the photographer becomes a witness that indeed the details of the picture are true. The cost of such photography is usually built into the construction contract and can be quite lucrative for the photographer.

MODELS AND RENDERINGS

Models and architectural renderings are also bread-and-butter work for the photographer and while at first glance may seem a rather mundane aspect of the business, can present as much, if not more, of a challenge in their reproduction. Architectural renderings, which usually preceed model construction, require skills in copy work and may be used by the architect as a sales tool in carrying a limited initial assignment on his part to a second level of involvement with a project.

You'll find that arranging two studio lights so that one is placed on either side of the camera at a 45-degree angle gives the simplest and most effective copy lighting. A polarizing filter should be used over the lights (or lens) to eliminate the possibility of glare, flare and stray reflections. Check the uniformity of illumination across the entire surface of the origi-

nal with an exposure meter, taking readings in random areas as well as in the center and each of the four corners.

And don't forget to take the additional bellows extension used into consideration when calculating exposure. Whenever the original is closer than eight times the focal length of the lens in use, the effective aperture will no longer be the same as that computed by the meter. Thus, if you're working with a 6½-inch lens, additional exposure must be given whenever you're working at a distance of 54 inches or less. If you accidentally overlook this factor, you'll underexpose by as much as three-quarters of that required when copying at a same-size or 1:1 ratio.

Photographing an architectural model amounts to tabletop photography on a professional basis. The idea behind model photography is to make it as realistic as possible and in some cases, to simulate reality in a variety of different environmental possibilities. Model pictures are invaluable to the architect for this reason and should be approached in that manner by the photographer. To achieve the desired sense of reality, you'll have to consider camera placement, lighting, composition, perspective and scale, just as you would when working with a real building.

Problems occasionally arise when working with such models because the photographer tends to overlook the fact that he has absolute subject

2

3

1. *Before-and-after remodeling pictures are popular with contractors. They can also be sold to congregations or groups raising funds when the pictures involve buildings such as this church interior.*

2. *High and low views of structure may provide not only a different angle, but for contractor or architect an entirely different reason for picture. At top, top of new building appears to be the upper story, but in lower photo we see upper equipment housing on roof of new structure. There's also impression that building stands alone from older ones beside it. This view more closely resembles architectural renderings of buildings in lighting and angle point.*

3. *It's often possible to separate building from older connecting ones by carefully framing it in natural setting. Unless you look closely beside tree, you do not realize building is actually there. Darkening tree by burning-in helped effect.*

control—to put it quite bluntly, there's a human tendency to become sloppy in your approach—after all, you're only working with a toy, right? Wrong—you should be just as professional as when you're on location shooting a real building. You'll find that architectural models lend themselves well to a greater variety in camera positions simply because you have no natural or man-made obstructions to worry about and a variety of higher than normal camera angles are possible simply by elevating the tripod or lowering the model.

In general, you should attempt to light the model to show the effect of sunlight. This helps to determine exactly what the structure will look like in its natural setting. Mid-morning or mid-afternoon sunlight is easily simulated by using the 45-degree portrait lighting pattern; the overhead lighting of high noon can be achieved by directing a flood at a light colored ceiling over the model, while the appearance of late afternoon lighting comes by dropping a spotlight to slightly above table level and aiming it across the set. Floodlight is usually preferable as a source because it can be easily controlled and balanced with the use of a rheostat. And don't overlook the possibility of placing small lights inside the model to simulate how the building will look at night. By dropping the spot to the model's base at one side, you can produce a twilight effect that's variable in degree and intensity by a slight up or down

movement of the light.

You won't have to worry about foreground control, as a nice clean foreground is usually provided with the model, but backgrounds can pose problems. While the background should not detract from the subject, it should be thought of as a means of further enhancing the final picture. You might use a regular painted studio backdrop or even seamless background paper but both tend to lessen or destroy the feeling of reality.

There are several ways to achieve this effect. The simplest is the use of a painted cloud backdrop, but this may not always blend well with different models. Then there's the possibility of moving the model outdoors and working with the real thing, but this

also has its disadvantages. If your slide file holds a sufficient variety, rear projection of scenic backgrounds can be used to provide a choice of many different effects at a moment's notice.

The greatest flexibility and control comes in shooting against a plain backdrop, adding clouds and darkening the sky during printing, but this also requires a rather extensive file of sky/cloud negatives. And for that finishing touch, you might print in a tree branch along the top or one side—if the craftsmanship of the model is good, few people will be able to tell it from the real thing once this has been added to the picture..

If the model is somewhat less than perfect in construction or craftsmanship, it's often possible to hide flaws by slightly diffusing the print. This can either be done when photographing the model or added later in the darkroom by printing through a wire or gauze screen. When choosing a camera position and selecting the lens to be used, watch perspective control as you'll be working at rather close distances and perspective can change rapidly under these conditions. It may also be a good idea to include objects that will provide comparative scale, such as miniature automobiles or even figures. If so, select ones with an accurate scale that are as realisitic as possible and position them carefully in the same plane as an important aspect of the model but so they remain subordinate to it in interest.

DETAIL SHOTS

Under some circumstances, it will be necessary to provide both overall exterior shots and a series of detail pictures, especially where the structure benefits from a number of ornamental details, design innovations or interesting peculiarities, as overall pictures do not always reveal the true relationship between walls and space. You'll find that a series of detail photos will often reveal more about most buildings than the simple, all-encompassing picture, yet that single picture is necessary to relate the structure to its surroundings. As a general rule, try to capture the beauty of architectural detail to reveal a structure's character. This often requires a completely different approach in terms of composition, lighting and camera position.

You'll find that detail photography may mean working at very odd or awkward angles, or even in unusual positions. It may be necessary to place the camera quite close to the ground or near the jet line of the roof

1

2

to capture the required detail. All of which means that you'll probably have to devise some rather ingenious ways to get the camera into place. Higher than normal viewpoints can be achieved with a shooting platform on the roof or a car or truck, or it may be possible to shoot from the window or roof of a nearby building. Some vehicles designed for use in warehouses or at construction sites have platforms that can be elevated to high positions; the answer to such problems depends upon how badly an ingenious or enterprising photographer wants the picture—where there's a way, he'll find it. For very low positions, you can cut down the legs of an old wooden tripod and if you're using a Sinar view camera, its accessory Binocular Reflex Magnifier will make ground-glass viewing at low (or even high) angles a snap.

Detail is shown off to its best advantage when sidelighting is available to create the proper visual relief. Flat frontal lighting destroys all sense of depth and relief and for this reason, should be avoided. Contrast balance is important here, as sidelighting that's too strong will create deep shadows and washed-out highlights. You may even find it necessary to use a weak supplemental light as a fill in bright sunlight; on overcast days, supplemental lighting will often be required to strengthen the shadow pattern. In either case, it should be properly balanced to avoid an artificial look in the print.

1. Construction record or progress shots are usually dull and mundane, like these two pictures, but they don't have to turn out this way.

2. While much depends on structure and photographer's imagination, it is possible to inject a bit of drama into progress shot, as shown here. But you should be absolutely certain you know what architect or contractor wants in record shots before attempting to be arty, no matter how good the opportunity appears to be.

3. Architectural model provides the opportunity to display your ability at professional tabletop photography. Lighting is usually arranged to simulate sunlight, and architects will often request that model be photographed with "sunlight" at exact angles to determine what building will look like in its natural setting.

4. Backgrounds for model photography should not be distracting. While most like to shoot against plain backdrop and darken "sky" during printing, some photographers print-in clouds. Here clouds are real, as model was shot outdoors, but trees were printed-in from a second negative.

5. When construction of model exhibits less than perfect craftsmanship and close-ups are required, try printing through wire or gauze screen for a slightly diffused effect.

Applying Your Talents

A lens with a considerably longer than normal focal length is usually necessary for detail work to provide the image size and clarity required. While it may be possible to enlarge a portion of an overall photo, this is not recommended unless absolutely necessary; while it will be correct for the overall area, the lighting may not do justice to the details when blown out of proportion to the whole. The loss of definition in the image quality of a print made from a smaller segment of a negative is bound to suffer by comparison to full negative prints and work of less than uniform quality should never be sold to the client.

COLOR

While the photography of architecture in color is not really a special application as such, it has become a growing and important aspect of the field over the past decade. As Kodak has made color easy for all to work with at the same time that television has brought color into the living room, the public has become quite color-conscious, with more and more clients specifying it in favor of black-and-white pictures. Yet few if any professionals could make a satisfactory living from color photography alone, for black-and-white is still the accepted medium of the architectural photographer.

Our point is simply that if you're not completely at home working in either medium, you'd better brush up on your color techniques and the attendant problems of light balance, filtration, color composition, etc. Like any other aspect of photography, successful color pictures result when the photographer is able to bring all of the existing factors to bear in pro-

1

2

ducing the best possible picture. The basic rules of architectural photography also apply to color studies but in addition, the use of color brings with it the necessity for familiarity with the tools of color—you should be prepared to work in either medium with equally good results.

1. Although photographer may not have final say, addition of accurately scaled toy automobiles or dolls will give viewer something for size comparison. Positioning of such objects requires care to insure that they enhance rather than detract from the final result.

2. Modern buildings, particularly those by famous architects such as this Greek Orthodox Church by Frank Lloyd Wright, are always a challenge to photographer. Sometimes challenge is best met by simple, straightforward series approach that includes detail shots. This aerial view is "scene setting" as it shows gardens, circular pool and overall structure with no particular emphasis on any single part of structure or grounds.

3. Another view from south gives impression that building is surrounded by foliage, and use of infrared film emphasizes foreground greenery.

4. Close-ups such as this emphasize details of outside windows, metal roof and ventilators, but require means of positioning camera differently. You can imagine loss of quality if a section of other photos were blown up to give this image size.

5. From ground level, building alone creates its own drama. No angle shot is necessary to improve its appeal to viewer of photograph.

3

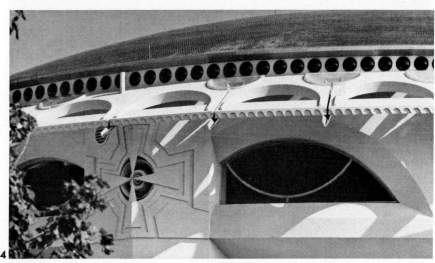

4

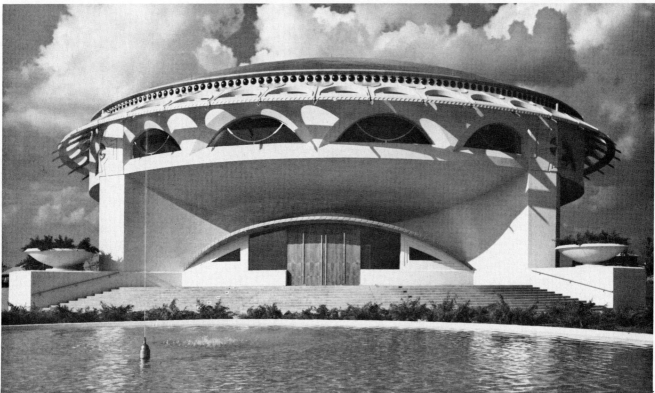

5

Processing for Perfection

It's time now for the final test of your skill. Whatever talent you have as an architectural photographer will stand or fall in the darkroom when you develop and print the negatives. Many who work in the field regard negative processing as the most important aspect of good architectural pictures and they can certainly build a satisfactory case for this point of view. Regardless of how much care and forethought or skill in technique and treatment you've devoted to the exposure, it's all wasted if those negatives don't deliver the exact values needed from them.

Push-button photography has been made so easy for us these days that the rather mundane task of negative development is all too often taken for granted. There's a great tendency to rely on the built-in latitude of modern sensitized materials and chemicals to compensate for a lack of knowledge, carelessness or even mistakes on the part of the photographer. Many professionals simply turn over their exposed holders to a custom lab and go on to their next assignment, depending upon others to pick up where they left off to carry the job to its logical end. While the crush of time and pressure of assignments make this more profitable than concerning himself with the intricacies of processing, any self-respecting professional should be capable of doing it himself if necessary.

Good architectural photographs involve the accurate recording of tonal and textural values and with this in mind, it becomes apparent that unless negative development is carried out with the same attention that's paid to exposure of the film, the desired values just won't be there. We know of working pros whose darkroom philosophy is a simple formula—"soup everything for seven minutes in ZZ fine-grain developer." These photographers also complain a good deal about the fact that modern emulsions and papers seem unable to capture the full tonal range of a subject,

pointing to the "good old days" before World War II when "manufacturers didn't skimp on silver" and films and printing papers had "a range of values they are unable to capture today." Nothing could be further from the truth, but try and get them to reconsider their attitudes toward negative development!

The requirements of a good architectural negative are threefold: highlights should have ample gradation, shadow detail should be retained without flare or fog density, and textures of the materials that compose the subject should be fully revealed. While any standard developer will bring out the latent image on a negative, not every one will do so in a way best suited to your purposes. For example, Kodak publishes data on four of its developers for use with infrared emulsions. While you can develop infrared film in Microdol-X, D-76, DK-50 or D-19 and obtain a printable image, the degree of contrast in the final negative is greatly affected by the choice of developers. Microdol-X provides a rather flat contrast index curve when compared to the maximum contrast inherent with D-19's use.

Commercial developers are compounded in many different ways these days; some to give a hard negative and others to deliver a soft image General-purpose developers are formulated to meet average needs and some work better with over-exposed negatives while others are more suitable for use with underexposure. The point to be made here is simple enough—there is no single all-purpose developer that will maximize negative values under all circumstances, despite the common exhortation that you should work with a single film/developer combination.

While it's true that as you become familiar with the qualities of certain emulsions and developer combinations, you'll tend to narrow the number of those with which you work, this should not be carried to the logi-

cal extreme of one film/one developer for everything you do. As we pointed out in considering film and filters, you should choose the emulsion to be used according to the assignment and its requirements. Of equal importance is the selection of the proper developer to complement your choice of film.

In our discussion of interiors, we mentioned the old saying, "expose for the shadows"; the other part of that axiom is to "develop for the highlights." While this is a good rule of thumb, it's not completely practical for the working photographer who must keep up a constant work flow. It requires that you be sufficiently familiar with your materials to vary the development time, increasing development for a low brightness range in the subject and decreasing it for a high range. Unless you *really know* what you're doing, this becomes little more than an educated guessing game that can create more problems than it will solve.

Probably the most practical advice is to follow the contrast index curve as a basis for negative development. Contrast index has replaced the older gamma system of measuring development contrast primarily because gamma did not give consistent results

1. Here's the essence of good architectural photography; an accurate rendering of tonal values and subject texture that can be achieved only by correct exposure, proper development.

2. Had shadows under overhanging roof of this school building been any deeper, total effect would have been ruined. Even if your exposure is right on the button, you cannot depend upon a pat formula to produce optimum negative values.

3. Contrasty mood of unusual building such as this is emphasized by camera placement that makes corner a strong center of interest. Darkening foreground slightly in printing removes visual obstruction of emptiness and if trees are not present to provide "frame" while taking picture, they can be added by double printing.

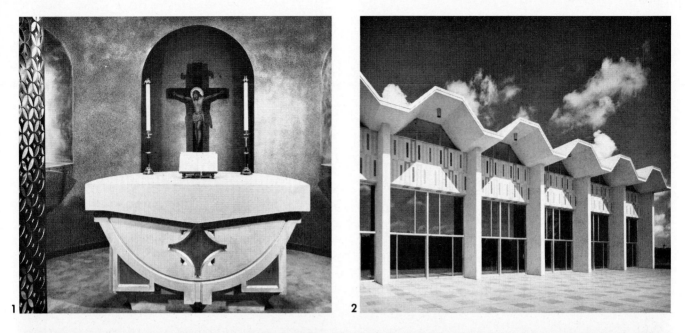

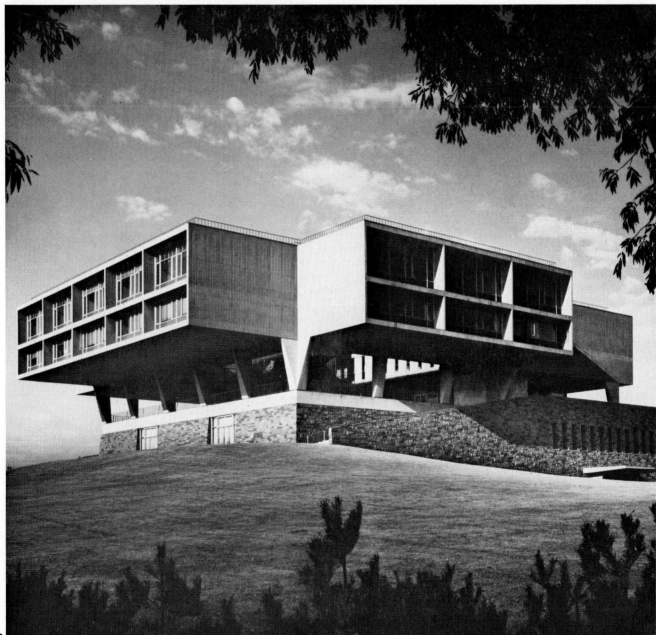

Processing for Perfection

from emulsion to emulsion. Contrast index is the gradient of a straight line drawn between the highest and lowest densities useful in a normal negative and is plotted on the emulsion's characteristic curve. This allows you to control alterations in negative density by development and still get uniform results every time.

To use the contrast index curve system, expose and develop a set of identical test negatives according to the time scale shown below the curve graph. Use a standard temperature (68°F is recommended), fresh chemicals and a uniform system of agitation. While 0.60 is considered to be normal for continuous-tone work, you may find that higher or lower contrast than that provided at 0.60 best suits your requirements. Once you've established the contrast index value in

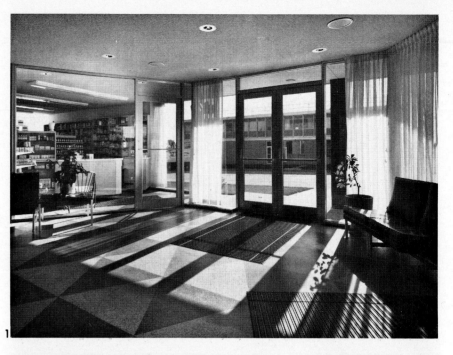
1

1. Judicious use of fill lighting with that provided by sunlight streaming in through windows makes this store entrance a totally satisfying photo. By holding back foreground lighting, doors become center of interest, but interplay of tonal values creates mood here. Overdevelopment would block details in curtains; too little would destroy fine shadow detail.

2. Here heavy shadows were deliberately created at left in order to make stairs the center of interest instead of just a central part of room. Banks of lights were placed in front of and at top of stairs to create illusion that stairway was photographed by existing light. With such a wide range of tones present in scene, proper development was as much a key to picture's success as was the exposure.

3. Contrast Index is gradient of a straight line drawn between points of highest and lowest density on the film's characteristic curve. Contrast index of 0.56 to 0.60 is considered normal for continuous-tone negatives.

4. Contrast Index curve for Kodak Infrared Film 4143. This chart can be used to determine correct developer and time of development for desired degree of contrast. Note the great difference in degree of contrast provided by Kodak D-19 and Kodak Microdol-X developers.

5. Late afternoon contrasty lighting posed real problem that was not successfully overcome in this picture. Texture in highlight areas cannot be seen, while shadow detail was almost completely lost. This negative would have been better developed using the water-bath treatment to hold back highlight development while allowing shadow detail to reach its maximum. Dodging and burning-in offer little with subject as complex as this.

6. Hard rubber or plastic developing tanks such as this Baco are preferable for sheet film development as they are highly acid resistant and light proof.

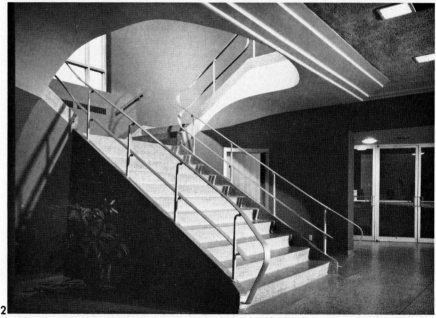
2

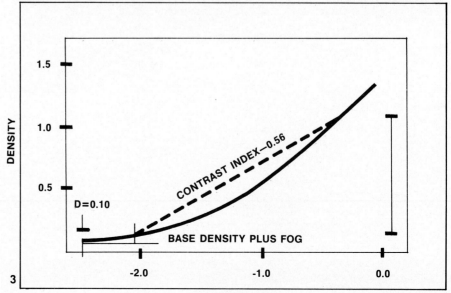

CONTRAST INDEX—0.56

D=0.10

BASE DENSITY PLUS FOG

DENSITY

1.5

1.0

0.5

LOG EXPOSURE

-2.0 -1.0 0.0

3

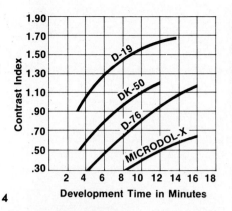

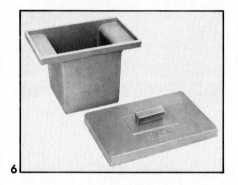

4

5

6

this manner, you can then obtain the same density range with any other film/developer combination by simply developing to that contrast index. You must, however, use the same temperature and agitation system as you did with the test negatives.

When faced with extremes of contrast such as those provided by the combination of very bright sunlight and predominantly deep shadows, you'll have to expose for the shadows to obtain the essential detail and this means a gross over-exposure of highlight areas. But there is a trick to bring the two into a manageable proportion by balancing out the extremes in exposure through development. In essence, the trick is one of letting shadow detail develop while retarding the highlights from complete development and is known as the "water bath" treatment.

A negative to be developed by this method is placed in the developer for a brief period until the image barely starts to appear. This will usually take between 20 and 40 seconds, after which it's removed from the developer and placed in a tray of plain water (same temperature as the developer), where it's left without agitation for two minutes. The negative is then returned to the developer for another period of time double that of the initial immersion. Remove it and return to the water bath for four minutes. A third trip follows in the developer for 20 seconds and a final water bath treatment of 10 to 15 minutes should complete the process, giving an even development of the subject instead of

the expected contrasty one with blocked highlights or lost shadow detail in its image.

Inspect the negative by the green safelight to make sure that development has been carried far enough; if not, repeat the alternate developer/water bath treatment until the negative's density is sufficient. If you use a desensitizer bath first, it's possible to develop by inspection throughout the entire process. As this technique will provide maximum control, giving the best results with tricky problems of glaring windows, high levels of reflection, etc., it deserves extensive experimentation.

Results of the water bath treatment for developing contrasty negatives are very satisfactory and at this point, you may wonder exactly why. The answer is simple enough—shadow detail, which received less exposure than the highlights, absorbs the same amount of developer as the highlight areas. Under normal development conditions, the overexposed highlight areas would develop much more quickly and vigorously than the shadow areas, but when the water bath treatment is used, development of highlights stops while the negative is in the water. But the slower and less vigorous shadow detail continues development. Reimmersion in the developer recharges both areas of the negative and the process repeats itself until the entire negative is satisfactorily developed. As a result, the shadow detail areas develop normally while the overexposed highlights develop less than they otherwise would, balancing the great discrepancy in exposure.

The ability to develop individual negatives to a specific and often quite different density range is one of the most valuable assets of working with sheet film. As sheet film can be processed either by tank or tray, it's

a matter of individual preference as to which technique you use, but the procedures differ somewhat. Using a tank requires transferring individual sheet film from the holders into developing hangers. As each hanger is loaded, it's placed in a hanger rack and when all are ready, the timer is started, the rack lowered slowly into the developing tank and tapped sharply as a precaution against air bells. At the end of the first minute of development, the hanger rack is lifted out of the developer and tipped about 90 degrees to one side, reimmersed, lifted again and tilted about 90 degrees to the opposite side before being replaced in the developer. Repeat this procedure once during every minute of development.

Developing sheet film in a tray is somewhat trickier but just as effective. The exposed sheets should first be completely immersed emulsion side up in water to prevent them from sticking together in the developer. After all have been prewet in this manner, slide the bottom sheet from the water by its edges, set the timer and put the sheet of film into the developer emulsion side up. Transfer the other sheets in the same manner, making certain that each is completely covered by developer before adding another. Agitate the film by gently lifting each of the tray's four sides in turn about one inch above the counter. When the timer signals the end of development, move the films to the short-stop one by one, starting with the bottom sheet. Lift each sheet by a corner and let it drain before placing in the stop bath.

Once you have a properly exposed and developed negative at hand, there should be no difficulty in making the final print but a few hints are in order. While the choice of paper surface and finish is an individual one, a glossy double-weight paper is

Processing for Perfection

probably the most suitable, as it contains a depth of tone and brilliance impossible to achieve with matte finishes. A semi-matte will occasionally approach the brilliant translucence of the glossy finish, but under normal circumstances, architectural photos should be sharp and crisp with clearcut definition; there's little reason to work so hard to obtain maximum subject sharpness if you're going to hide part of it in the final print.

Negatives should be exposed so that the print will develop fully in 2½ minutes—no more, no less. Our photographer friend who believes that seven minutes spent "souping" his film will give him a printable negative has his counterpart under the enlarger who feels .that settling on a uniform printing exposure and varying development works just as well—if the print comes up completely in 30 seconds, so much the better, according to his philosophy—he can cut his darkroom time considerably this way. Such thinking probably accounts for 50 percent of the muddy prints that constitute an overly large portion of today's architectural photos.

If you expect the paper to deliver the rich, deep blacks and good clean whites of which it's capable, correct exposure of the final print is absolute-

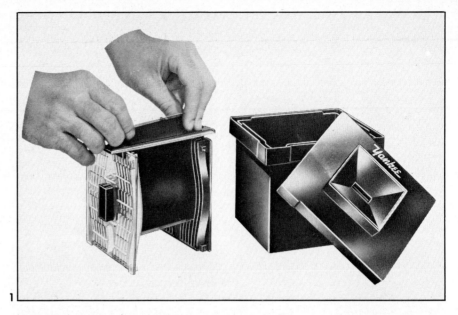

1. *Yankee Agitank for sheet film features rack that replaces individual sheet film hangers and can be adjusted to accept five different film sizes. While you would otherwise require three tanks for solutions, Agitank with its built-in pour spout can be used just as any roll-film tank, but development by inspection is not recommended as you might reinsert film incorrectly and scratch the adjacent negative in so doing.*

2. *Predominating light tones in this school hall make exposure calculation somewhat of a headache, especially with overhead lights. Use of polarizing filter would have reduced glare on wall and windows, but duration of exposure required as result would have introduced possibility of movement on part of girl positioned for relative scale. In this case, waterbath treatment would have brought up detail in corrugated light panels without affecting rest of subject.*

3. *In room like this library where lighting changes from extreme brightness to considerably lower value, you might be tempted to over-compensate in either exposure of development, but in doing so you'd destroy much of the feeling of room. Some detail was retained in highlights but table glare should have been corrected by burning-in while printing. Incidentally, composition could have been improved immensely by moving people to oval table at right foreground; as they are, they are lost in visual maze of furniture and wall racks.*

4. *Here's a near-perfect example of proper lighting balance by exposure and development. Natural light was used alone and overcast sky outside did not create harsh contrast. There are, however, several other faults with shot, and as budding architectural photographer, we'll let you put on your thinking cap to decide how it could have been improved.*

5. *Darkroom convergence correction can be obtained by tilting negative and lens (A), tilting negative or lens and easel (B), or tilting only easel (C). In the case of A, tilt of lens produces uniformly sharp image even with lens open wide; C requires focusing at point X and then stopping down lens to its minimum aperture to obtain critical focus over the entire area.*

6. *This church shot suffers from a variety of converging lines and was photographed this way deliberately to show the difference between uncorrected or poorly corrected convergence that occurs while taking picture and what happens when you introduce distortion control in darkroom via a tilted easel.*

7. *Tilting easel and changing to longer focal-length lens results in this. If you did not have original with which to compare it, you might not recognize compression of horizontals, especially noticeable here in windows and smaller spire at right.*

ly necessary. Overexposing according to our sloppy friend's technique and then curtailing development will give dirty looking, grayish-blacks with little depth or tone. Underexposed prints that have been forced in development turn out fogged and flat with no brilliance—only exposure and development that's right-on will deliver the sparkling velvet blacks you want.

Before leaving the darkroom, let's look briefly at convergence control under the enlarger. If you were unable to correct verticals completely with camera adjustments because of distance or lens limitation, a limited amount of correction can be produced while enlarging. If your enlarger has a provision for tilting both the negative carrier and the lens board, the technique will produce acceptable results to a point. If only one (or none) of these enlarger corrections is available to you, the easel can be tilted but the degree of correction diminishes quite rapidly and while you can correct unparallel verticals, this introduces a falsification of horizontals—circular domes take on a semi-oval appearance with extreme correction of this type. Because of the difference in light ray travel from

negative to paper, there'll also be a tonal change from that of a straight, uncorrected print. And so the question becomes one of deciding which is the lesser of two evils—slightly converging verticals or slightly condensed horizontal proportions, and a change in tonal values.

As there are practical limits to what can be accomplished with this technique, you must focus carefully. If the enlarger's negative carrier or lens board can be tilted, focus on an area about one-third the distance from the easel's upper edge with the lens wide open, then stop it down as far as possible to achieve overall critical sharpness. As the distance between lens and easel increases, so does the ease with which uniform sharpness is achieved, thus you may find it more practical to work with a longer focal length enlarging lens than under normal circumstances.

Although you can compensate for a slight amount of vertical convergence in this manner, it's far better if at all possible to avoid the necessity for such extreme measures and the resulting doubtful advantages offered—have the right equipment at hand and use it correctly. ♛

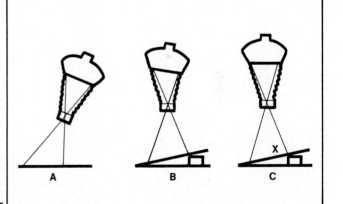

Looking at the Business Side

By fortunate coincidence, the architectural field is one aspect of photography that's almost wide open for the enterprising craftsman who wants to make a name and a lucrative living for himself. Unlike other specific areas such as fashion or glamour photography, there are very few established "names" working in architectural photography, despite the large number of such pictures turned out every year.

While even the most casual photographer can occasionally sell a picture or two to be used on postcards, we assume that you're serious in your intentions to turn a hobby into a profession. To make substantial sums at the game, you'll need three things: the right equipment to do the job, a carefully plotted plan of action, and the ability and willingness to carry out the plan in a business-like manner

The basic equipment requirements were covered at the beginning of the book and despite the sharp appearance of a new camera, we remain convinced that a minimum investment, preferably in used equipment, should be made at the start. Unlike today's highly sophisticated SLRs and TLRs, with their complex electromechanical systems, the design of view cameras has actually changed very little over the past 30 years. For example, Deardorff view cameras still use the same basic design that first appeared under the company's name in 1923. Although the company makes numerous small improvements from year to year, its last major design change came in 1948. While the Dutch-made Super Cambo certainly looks more modern, both cameras will do the very same thing. Our favorite architectural photographer started in business with a second-hand 8x10 view camera and lens that cost him $40. After spending the next

three years learning the trade, he invested another thousand and today, spends his winters in Florida where he will interrupt his golf game to take a shot of your bungalow, but only if he's coaxed sufficiently.

There are three primary purchasers of architectural photographs—architects, contractors and publications. In order of the frequency with which architectural photos are seen, the publications would appear to offer the largest market, but surprisingly, contractors are really the major market. While they are also among the most critical clients you'll have, at the same time they're the least interested in artistic pictures. Most contractors are simply interested in "record" shots and every large city contains a number of photographers who take what are probably the most mundane pictures in the world while making a handsome living at it; they contract to take pictures showing the progression of work on construction jobs. While progress photography is one of the least understood and most obscure aspects of architectural photography, it's also a good bread-and-butter route for those who seek to rise to greater heights in the business.

What can construction photography bring in the way of income? As contracts are often let on a "bid" basis, amounts will vary but in most cases, it proves to be a lucrative arrangement for the photographer. One construction photographer we know in Chicago recently reported that on the average he takes 10 location shots a day—all on the same site and all in black-and-white. As he's required by contract to furnish up to 25 prints of each shot, he's converted a flourishing custom photofinishing business into a facility solely for this work and the business continues to grow—faster than ever.

But aren't contractors ever interested in a really "good" photo of the structures which they build? The answer is both yes and no. The artistic picture does not suit their needs, but it's not difficult to sell them prints of the shots you may take for the architectural firm involved. And this brings us to a consideration of working for people who are not only super-critical of your work, but are also interested in showing the brick-and-mortar to best advantage.

Working for architects often begins with copies of the various sketches and renderings, through photos of the models in varying stages and ends with interior/exterior pictures of the completed building. Since individual architects are often known for their use of particular materials to create various moods, lines or shadows in their work, you need to be absolutely certain of what your client wants when you accept an assignment. This is one reason why many photographers work hard to establish sufficient rapport with an architect or architectural firm to inspect previous photographic work done for the client by

1. Here's an example of how to really profit from your work. This dental lab picture was made for contractor, but was also sold to several firms supplying the equipment in picture.

2. Church interiors, especially when remodeling is concerned, can be small but lively sales items involving not only contractor and equipment suppliers but also members of the congregation and the church's historical records.

3. Installation of industrial equipment in control rooms, engine rooms and other mechanized centers usually involves several subcontractors, each of whom will have some interest in obtaining pictures of how their piping, wiring, tubing, boilers, gauges, etc. contribute to the whole, especially if application is somewhat unique.

1

2

3

others—to determine what is and is not acceptable.

One very successful architectural photographer always takes three pictures of every angle in or outside the building he's assigned to photograph. One is for the architect, the way he *says* he wants it. The second is also for the architect, but the way the photographer *believes* he *really* wants it, and the third is for himself, the way *he* thinks it looks best. One of the three is usually satisfactory for the architect, one for the contractor and one goes into the file to show future clients. Just which one fits each category is always a toss-up, proving that neither the architect nor the photographer can read each other's mind with 100 percent accuracy.

Working exclusively for architects seldom proves as financially rewarding as working with contractors and construction companies; their needs are different and more limited. While the photographer who can become known as a reliable producer of quality work may find it possible to be placed on a retainer with one of the larger architectural firms, most do not have sufficient work to maintain a staff photographer. The beginner who wants to work with architects should make up a portfolio of building pictures and then visit various firms to show the kind of work he can do. Another profitable exercise comes from watching the announcements of building contracts, and a friendly contact at the city building permit office is also not a bad idea—both sources can keep you informed as to exactly what's happening on the local scene.

If you're a versatile photographer, there's a large market for both good and unusual pictures in home-building and decorating magazines. Even though many such magazines have their own staff photographers, there's still a constant search and demand for fresh new material. If you're fortunate enough to be a reasonably good writer, you can often sell stories accompanied by your pictures to these magazines. The problem here of course is in getting the photos, as even unusual homes are not freely open to the roaming photographer. But we've found flattery to be the easiest entry to interesting places, as most homeowners actually believe that their houses should appear in *Better Homes & Gardens.*

Once you've established a track record by selling a few pictures to these magazines, they may be willing to discuss assignments in your area. Occasionally, such assignments are preliminary to the appearance of the

1

magazine's own crew to do the ''real'' photography, in which case they'll ask you to obtain a variety of interior/exteriors. When this happens, it's up to you to prove with your pictures that you can do the entire job for them; it never hurts to do your best on any job.

In addition to the major homeowner publications, there are literally dozens of house organs, trade and regional magazines that purchase pictures of new buildings, unusual construction and specific buildings for a certain type of use. There are also a handful of do-it-yourself magazines that will buy pictures of interesting aspects of homes which can be used to accompany articles of interest to the home handyman.

Another approach is to work with established realtors in your area. Here's a side of architectural photography that's often neglected by the professional and a good one to help you learn the intricacies of photo-

graphing buildings. Make an arrangement with a realtor to photograph his new property listings for a nominal fee that will cover material costs. In return, he should agree to give your pictures as wide distribution as possible—in his office, listing books and advertising.

One of the most popular means of obtaining such pictures at the present is to hand an appraiser a Polaroid camera with instructions to ''be sure and take some pictures.'' Knowing nothing whatsoever about picturing a building in its most favorable stance, the poor fellow snaps off a few quick ones to keep the boss happy. Since the use of photos is one of the favorite techniques used by real estate people to sell buildings and homes, one wonders exactly how many sales have been lost by the glaring lack of attention to presenting the property in its most favorable light.

Your photos certainly can do nothing to harm his business, and if sales

2

3

4

1. You should learn to interpret buildings exactly as desired by the architect. Despite the fact that both sides shown are identical, the unusual texture of this Cancer Research Building in Milwaukee was highlighted just as its designers wanted by using cross-lighting and a red filter.

2. While this language lab installation was taken for the school, equipment suppliers bought heavily. Foreground reflections could have been avoided by using polarizing filter which would have also reduced glare emanating from ceiling lights. Don't overlook such fine points when working inside.

3. Be careful about dating your photos unnecessarily. This church has timeless appeal, yet the appearance of three older cars leads the viewer to the conclusion that the "new" building is actually older than it is. Where scale is desired, people are often a better compromise, but watch their clothing styles carefully.

4. Should you do interiors with or without people? From a practical standpoint, leaving out anything that will date the picture will give it a longer life, but the deserted feeling inherent in this hospital lobby could have been avoided by the presence of a nurse behind the counter.

take an upward spurt after you begin to provide his pictures, take full credit for the increase—no one will be able to disprove your claim. Approach smaller contractors in your area with a similar proposition. This will provide you with an opportunity to build a diversified portfolio while gaining experience at little more than the cost of your time.

In this way, you'll also gradually make the acquaintance of others interested in your work, which will lead to profitable assignments. Once you've decided to make the switch from non-profit to a profit basis, you'll find that commercial and industrial assignments will constitute the largest percentage of your business. Go after manufacturing plants, hotels/motels, banks and stores, shopping centers and plazas, and civic buildings, as they represent the greatest market for the average architectural photographer. All are excellent for advertising your business through brochures or

pamphlets and can lead to an expanded circle of contacts—public relations firms and advertising agencies, etc.—that will contribute to further success.

What to charge? Well, that's always a problem at the beginning; if you charge too little, you foster the impression that you'll work for nothing. But if you set your prices too high, you risk the possibility of losing out to another upstart (like yourself) who'll underbid you. There's no doubt about it, competition is terrific in photography today and to get the job, you should be able to price an assignment quickly, accurately and with assurance that you'll make a fair profit while delivering a quality product.

Anything we might tell you in terms of developing an equitable pricing structure would most likely be outdated by the time it reached print. A much better solution to this dilemma is to refer you to the *Blue Book of Photography Prices* published by the

Photography Research Institute in Carson, California. For a one-time cost of $29.95, you'll receive the basic pricing guide and a one-year subscription to the periodic revision service based on constant in-depth studies of current market prices. This pricing structure designed for professionals by professionals will keep you up-to-date with the latest trends and also makes a fine reference source when cagey clients demand to know how you arrived at your figures.

If you're really determined, you can make it in architectural photography once you've mastered the techniques of picturing buildings at their best. The two major reasons that many would-be professionals fail in their attempt to fulfill every camera fan's dream are a lack of talent and a lack of ambition; we assume that you have the former—now put it to work for you!

Architectural Marketplace

The following 45 publications are only a sample of the many and varied markets for the architectural photographer. As market conditions change frequently, it's best to address a query letter to the editor before submitting any material. Briefly recap your qualifications and ask for a sample copy of the magazine if it's not readily available in your area. Enclose a self-addressed stamped envelope with your query and always include sufficient postage for the return of any submissions you might make.

AIA JOURNAL, 1785 Massachusetts Avenue, N.W., Washington, D.C. 20036. A monthly professional journal for architects.

AIRPORT WORLD, 7315 Wisconsin Avenue, Air Rights Building, Washington, D.C. 20014. Monthly for airport operators, managers, architects. Uses features on modernizing airports, expansion of facilities, etc.

AMERICAN HOME, 641 Lexington Avenue, New York, New York 10022. Monthly consumer magazine for young homemakers with emphasis on decorating, building and remodeling. Photography done on commission only.

ARCHITECTURAL FORUM, 130 East 59th Street, New York, New York 10022. Monthly.

ARCHITECTURAL RECORD, 330 West 42nd Street, New York, New York 10036. Monthly for architects and engineers. Identify building by architect, location and owner when querying.

BETTER HOMES AND GARDENS, 1716 Locust Street, Des Moines, Iowa 50336. Monthly consumer magazine for middle-and-above income homeowning families. Photography is shot under the direction of editors.

BUDGET DECORATING, 699 Madison Avenue, New York, New York 10021. Bimonthly for architects, designers and owners. Emphasis on low-cost but effective interiors.

BUILDING DESIGN & CONSTRUCTION, 5 South Wabash, Chicago, Illinois 60603. Monthly for architects, contractors and consulting engineers. Material must stress the interrelation of the three fields which compose its readership.

BUILDING PROGRESS, 427 Sixth Avenue, S.E., Cedar Rapids, Iowa 52406. Monthly public relations publication for the commercial building field. Architectural excellence, unique design and unusual use of materials are of greatest interest.

BUILDINGS MAGAZINE, 427 Sixth Avenue, S.E., Cedar Rapids, Iowa 52406. Monthly for contractors and architects. Stresses the unusual approach, design, material and method of construction.

CANADIAN ARCHITECT, 1450 Don Mills Road, Don Mills, Ontario, Canada. Monthly for architects and planners. Predominently Canadian in approach.

CANADIAN HOMES MAGAZINE, Suite 1100, 401 Bay Street, Toronto-1, Ontario, Canada. Monthly rotogravure magazine included with 12 Canadian newspapers. Interested in homes and home improvement with a Candian application.

CHURCH MANAGEMENT, Commercial Building, 115 North Main Street, 201-12 Mt. Holly, North Carolina 28120. Monthly for ministers.

CONSTRUCTION SPECIFIER, 1150 17th Street, N.W., Washington, D.C. 20036. Monthly professional journal for architects, engineers and contractors.

DECORATING RETAILER, 2101 South Brentwood Boulevard, St. Louis, Missouri 63144. Monthly for independent paint and wallpaper retailers. Unusual store interiors desired.

DESIGN AND ENVIRONMENT, 19 West 44th Street, New York, New York 10036. Quarterly for city planners, architects, engineers, landscape architects. Formal in sytle, emphasis on the design of man-made environment.

ENGINEERING & CONTRACT RECORD, 1450 Don Mills Road, Don Mills, Ontario, Canada. Monthly for construction executives, public works officials, engineers with empahsis on Canadian scene.

FARM BUILDING NEWS, 733 North Van Buren, Milwaukee, Wisconsin 53202. Bimonthly for farm structure builders and suppliers.

HOME MAGAZINE, 441 Lexington Avenue, New York, New York 10017. Monthly consumer magazine for homemakers with specific interest in medium-size homes and interiors.

HOUSE AND GARDEN, 420 Lexington Avenue, New York, New York 10017. Monthly consumer magazine with emphasis directed toward homeowners.

HOUSE AND HOME, 3320 West 42nd Street, New York, New York 10036. Monthly.

HOUSE BEAUTIFUL, 717 Fifth Avenue, New York, New York 10022. Monthly consumer magazine with emphasis on decorating, remodeling for homeowners.

INTERIOR DESIGN, 150 East 58th Street, New York, New York 10022. Monthly.

INTERIORS, 130 East 59th Street, New York, New York 10022. Monthly with emphasis on industrial design, decorating, architecture and individual design.

KITCHEN BUSINESS, 1501 Broadway, New York, New York 10036. Monthly for planning specialists and fabricators. Pictures of outstanding institutional food service kitchens desired.

LANDSCAPE ARCHITECTURE, Schuster Building, 1500 Bardstown Road, Louisville, Kentucky 40205. Quarterly.

LEISURE HOME LIVING & LAND INVESTMENT, 13 Evergreen Road, Hampton, New Hampshire 03842. Annual for middle-aged readers with above-average income. Wants houses of unusual design, vacation home communities east of the Mississippi.

MAGAZINE OF APARTMENT LIVING, 260 North Rock Road, Box 18387, Wichita, Kansas 67218. Monthly for family apartment dwellers. Clear, factual and modern treatment of interiors.

MODERN STEEL CONSTRUCTION, 101 Park Avenue, New York, New York 10017. Quarterly for architects and engineers.

NAHB JOURNAL OF HOMEBUILDING, 1625 L Street, N.W., Washington, D.C. 20036. Monthly for housing industry.

PERFECT HOME MAGAZINE, 427 Sixth Avenue, S.E., Cedar Rapids, Iowa 52401. Monthly for home owners. Primarily a photo magazine dealing in building, decorating and remodeling; needs complete home coverage.

POOL 'N PATIO, 3923 West Sixth Street, Los Angeles, California 90020. Semi-annual for residential owners of swimming pools. Wants unusual pools with human interest treatment.

PROGRESSIVE ARCHITECT, 600 Summer Street, Stanford, Connecticut 06904. Monthly. Purchases black-and-white and color photos to accompany staff articles.

PROPERTIES MAGAZINE, 4900 Euclid Avenue, Cleveland, Ohio 44103. Monthly. Concerned with real estate and construction news; does not buy color.

SAN FRANCISCO MAGAZINE, 120 Green Street, San Francisco, California 94111. Monthly consumer magazine slanted to the middle-and-upper income readership, interested in architecture and city planning as it relates to the San Francisco scene.

SCHOOL MANAGEMENT, 22 West Putnam Avenue, Greenwich, Connecticut 06830. Monthly for public school administrators and board members.

SCHOOL PROGRESS, 481 University Avenue, Toronto 101, Ontario, Canada. Monthly for educational administrators. Deals with significant developments in education including architectural design.

SHOPPING CENTER WORLD, 461 Eighth Avenue, New York, New York 10001. Mcnthly for developers, real estate agents, architects.

SUNSET MAGAZINE, Menlo Park, California 94025. Monthly consumer magazine dealing with western living. Staff written but buys photos to accompany articles. Also publishes numerous one-shots dealing with homes.

WALLCOVERINGS, 209 Dunn Avenue, Stamford, Connecticut 06905. Monthly for wallpaper dealers. Wants photos of effective store interiors.

WALLS AND CEILINGS, 215 West Harrison, Seattle, Washington 98119. Monthly for contractors, manufacturers and architects.

WORKBENCH, 4251 Pennsylvania, Kansas City, Missouri 64111. Bimonthly for the do-it-yourself homeowner.

YOUR CHURCH, Box 397, Valley Forge, Pennsylvania 19481. Bimonthly for clergy and architects concerned with church planning, architecture, etc.